Drawing Nature

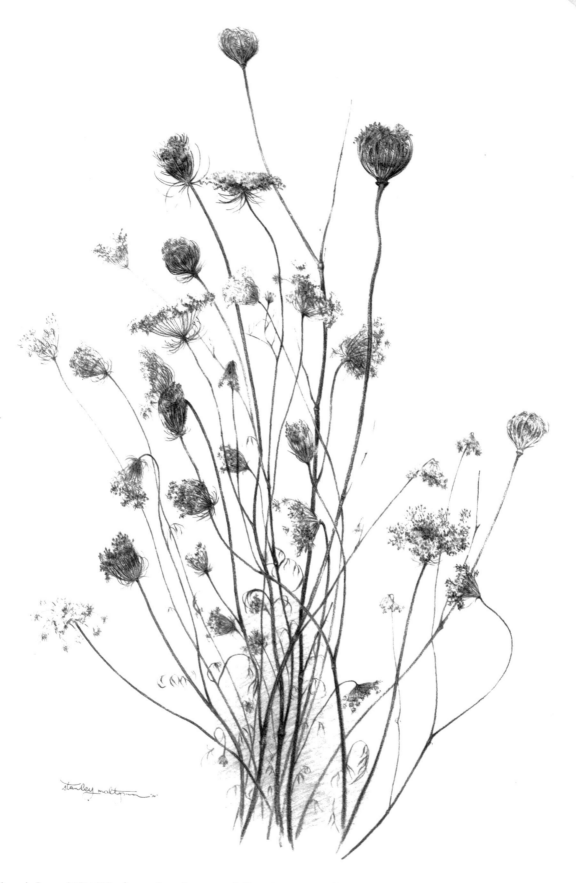

Queen Anne's Lace, 31″×22″, charcoal on Japanese (Misumi) paper. Collection of Rachel Maltzman.

Drawing Nature

Stanley Maltzman

NORTH LIGHT BOOKS
Cincinnati, Ohio

ABOUT THE AUTHOR

Stanley Maltzman is a naturalist artist whose affection for working outdoors stems partially from his years in Scouting and from living in the Hudson Valley region so rich in art history and scenery. Living in this environment makes it a natural for Maltzman to draw his inspiration from nature, and the drawings in this book attest to his love of this area and his willingness to share his knowledge with all.

Maltzman's drawings have been widely exhibited in museums and galleries around the country, including the American Academy of Arts and Letters, the National Academy of Design, the Capricorn Gallery, and the Carnegie Museum of Natural History.

His strong belief that good painting evolves from the ability to draw well leads to frequent invitations to lecture and conduct his "plein air" seminars and workshops for high school and adult students. Maltzman teaches professionally at the Hudson River Workshops in Greenville, New York. He has been featured in the April 1986 issue of *American Artist* and is listed in *Who's Who in American Art*. Maltzman is a member of the Pastel Society of America and the Hudson Valley Art Association.

METRIC CONVERSION CHART

TO CONVERT	TO	MULTIPLY BY
Inches	Centimeters	2.54
Centimeters	Inches	0.4
Feet	Centimeters	30.5
Centimeters	Feet	0.03
Yards	Meters	0.9
Meters	Yards	1.1
Sq. Inches	Sq. Centimeters	6.45
Sq. Centimeters	Sq. Inches	0.16
Sq. Feet	Sq. Meters	0.09
Sq. Meters	Sq. Feet	10.8
Sq. Yards	Sq. Meters	0.8
Sq. Meters	Sq. Yards	1.2
Pounds	Kilograms	0.45
Kilograms	Pounds	2.2
Ounces	Grams	28.4
Grams	Ounces	0.04

99 98 97 96 95 5 4 3 2 1

Library of Congress Cataloging-in-Publication Data

Maltzman, Stanley
Drawing nature / Stanley Maltzman. — 1st ed.
 p. cm.
 Includes index.
 ISBN 0-89134-579-5
 1. Nature (Aesthetics) 2. Drawing — Technique. I. Title.
NC825.N34M36 1995
743'.83 — dc20 94-40123
 CIP

Edited by Kathy Kipp
Designed by Leslie Meaux-Druley and Angela Lennert

DEDICATION

To my wife, Rachel, and my parents, Sarah and Abraham . . . they believed.

ACKNOWLEDGMENTS

Tish and Elliot Dalton of the Hudson River Valley Workshops, who started all this.

Gene and Barbra Green, whose cheery words and technical advice were an immense help.

Jerry Smith, whose photographic input added to the luster of it all.

Joel Savitsky, always there, always ready.

My daughters, Carole and Susan, and their families, the Kavanaghs and the Storys, who helped push the chapters through.

My friends at the Greenville Library, who made the research a lot easier.

The Tuesday-night sketchers, who were the springboard of many of my thoughts.

Gertrude Dennis and John Clancy, whose professional advice and encouragement through the years were of great inspiration in the development of my art, a cherished time.

The other Rachel in my life, Rachel Wolf, my editor, and her very capable associate, Kathy Kipp: many thanks and much appreciation for keeping the ship on its course with direction, knowledge and a good word.

Thank you.

And now for another mountain to climb. . . .

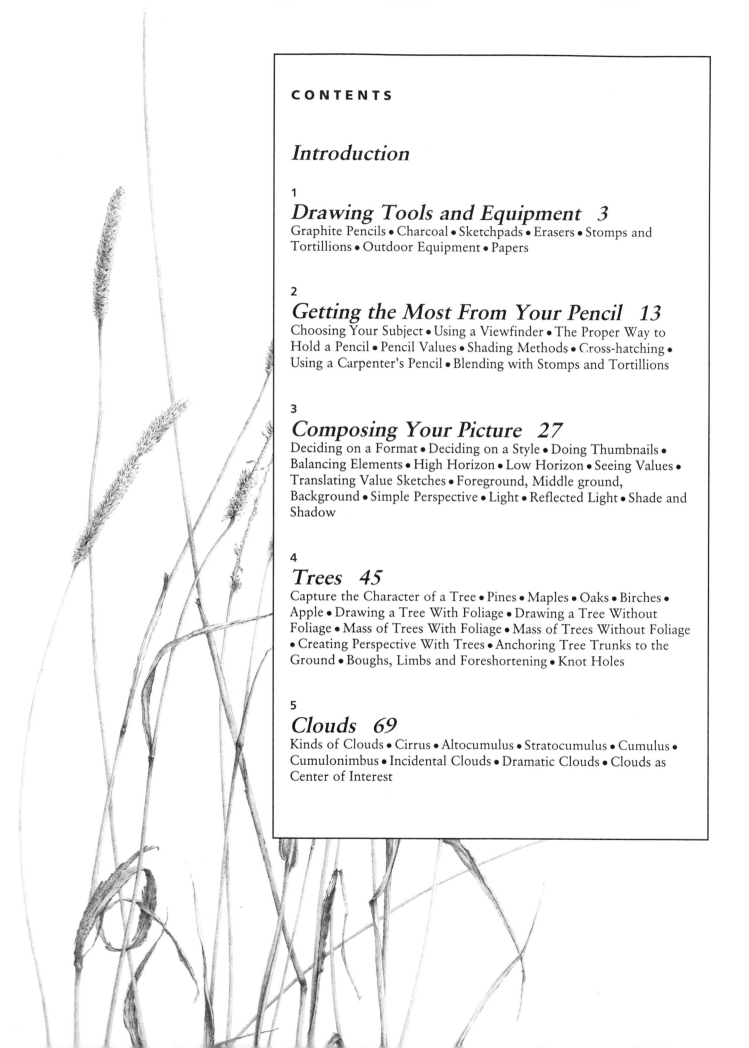

CONTENTS

Introduction
1

1
Drawing Tools and Equipment 3
Graphite Pencils • Charcoal • Sketchpads • Erasers • Stomps and Tortillions • Outdoor Equipment • Papers

2
Getting the Most From Your Pencil 13
Choosing Your Subject • Using a Viewfinder • The Proper Way to Hold a Pencil • Pencil Values • Shading Methods • Cross-hatching • Using a Carpenter's Pencil • Blending with Stomps and Tortillions

3
Composing Your Picture 27
Deciding on a Format • Deciding on a Style • Doing Thumbnails • Balancing Elements • High Horizon • Low Horizon • Seeing Values • Translating Value Sketches • Foreground, Middle ground, Background • Simple Perspective • Light • Reflected Light • Shade and Shadow

4
Trees 45
Capture the Character of a Tree • Pines • Maples • Oaks • Birches • Apple • Drawing a Tree With Foliage • Drawing a Tree Without Foliage • Mass of Trees With Foliage • Mass of Trees Without Foliage • Creating Perspective With Trees • Anchoring Tree Trunks to the Ground • Boughs, Limbs and Foreshortening • Knot Holes

5
Clouds 69
Kinds of Clouds • Cirrus • Altocumulus • Stratocumulus • Cumulus • Cumulonimbus • Incidental Clouds • Dramatic Clouds • Clouds as Center of Interest

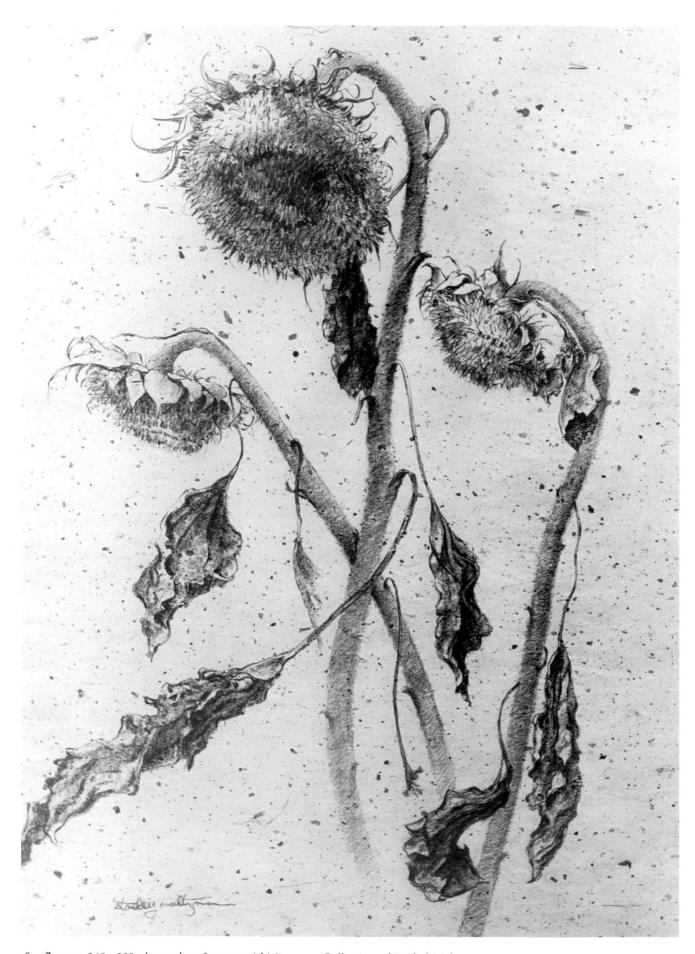

Sunflowers, 31″ × 22″, charcoal on Japanese (chiri) paper. Collection of Rachel Maltzman.

Introduction

Through the years, students have asked what inspired me to paint a certain picture, or what kind of pencil I use for drawing. My answer is, "It is a thousand-hour pencil." In other words, the secret is not the pencil . . . it is the work, the devotion and the love of drawing.

If you will give me your time, I will show how you can also create beautiful drawings. This book is designed to break down the inhibitions and limitations you may have encountered while drawing outdoors by teaching you how to interpret what you see.

Art starts with the business of seeing. Nature inspires you with her beauty, but unfortunately does not paint the picture. You, as an artist, must take the elements nature presents to you and interpret them in the light of your own feelings to create your drawing or painting.

Through step-by-step demonstrations, I will show you how to uncover the drama taking place around you—how to approach the subject with confidence, using charcoal and pencil techniques as well as some other special techniques. I will show how your paper becomes an integral part of your picture, as you plan—and improvise—your drawing to capture the mood of the moment. This, and much more, will enable you to discover and enjoy the pleasure of drawing nature outdoors.

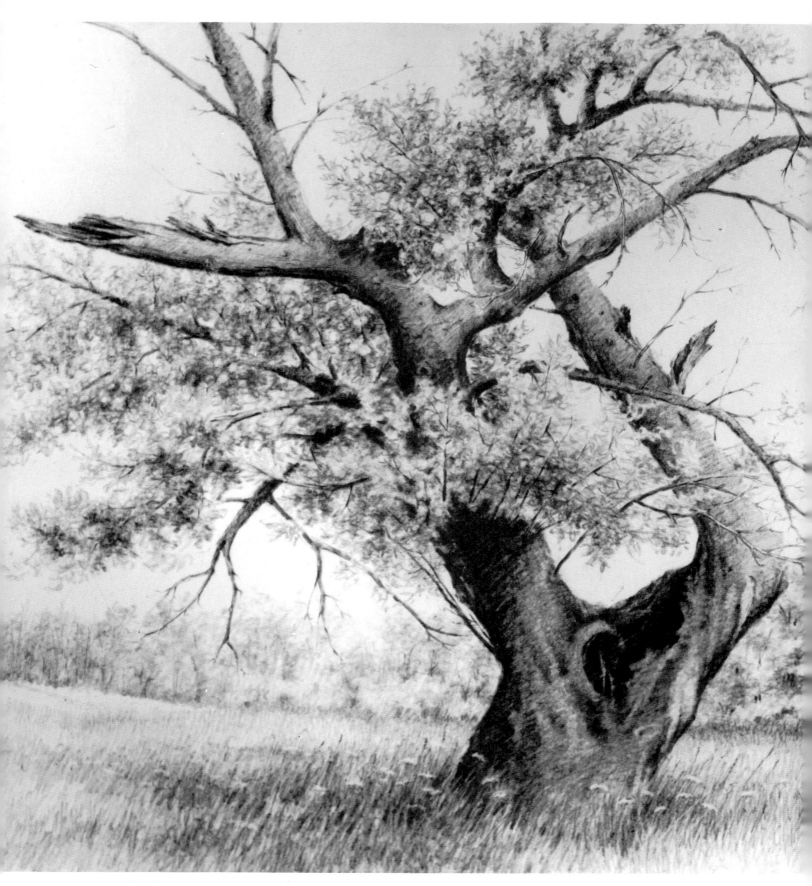

Remnants II, 22″ × 31″, charcoal on Japanese (Misumi) paper.

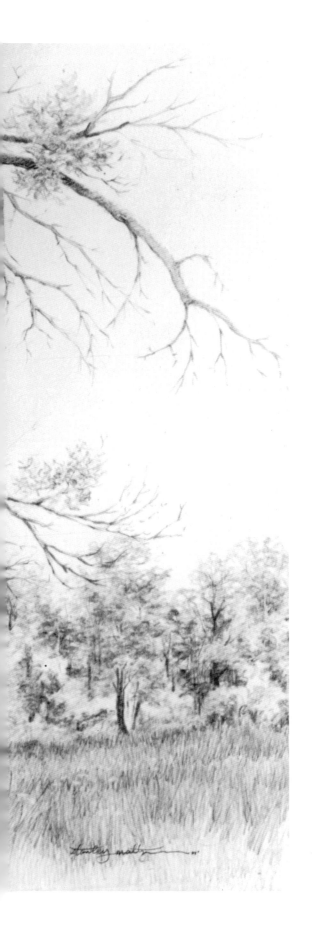

Drawing Tools and Equipment

Acquiring your drawing equipment can be exciting, and possibly a bit overwhelming. I still get a great deal of joy going into an art store and wandering around to see what's new. I get the same feeling when a new catalog comes in the mail. I find myself going through the whole catalog even though I might only need a few pencils. It is the thrill or anticipation of finding something new to work with — that magic pen or brush that somehow always eludes us. As time goes by, you are going to want to try other materials to draw with, and you should. That's part of the excitement.

In the pages that follow, I will acquaint you with some of the basic materials available for sketching and drawing outdoors. There are many more, but to get started, you will want to simplify the amount of equipment you carry with you.

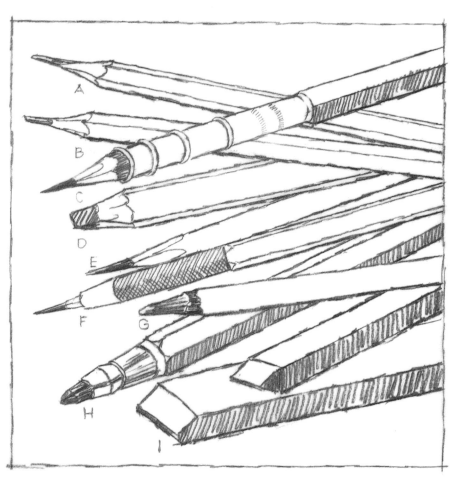

A. Artist's pencil, graphite
B. School or office pencil, graphite
C. Pencil extender
D. Carpenter's pencil
E. Water-soluble pencil
F. Mechanical pencil, thin leads
G. Woodless drawing pencil
H. Mechanical pencil, ¼-inch leads
I. ¼-inch and ½-inch rectangular and flat graphite sticks

GRAPHITE PENCILS

When we hear the word *pencil*, we immediately think of a piece of lead encased in wood. Actually, there is no lead in a pencil; it contains graphite.

On each artist's pencil, you will find a letter and a number—2H, 4H, 6H—as high as 9H. The *H* indicates *hard*. The higher the number, the harder the graphite, and the lighter the line. Pencils marked *B* are softer—2B, 4B, etc. The higher the number, the softer the graphite, thus giving a greater range of darks.

Other graphite pencils encased in wood, which will surprise you with their versatility, are the office or school pencils. The range may not be as great as the hard or soft artist's pencils, but you can ac-complish some nice sketches with them.

The carpenter's pencil consists of a wide graphite in a flat piece of wood, wonderful for laying in broad tones and values quickly. Other pencils in the graphite family are the water-soluble sketching pencils. They come in only three degrees of B. What makes them different is that when you finish your drawing, you can take a brush, dip it in water, and apply it to your drawing. The water breaks down the graphite, creating washes of grays from light to dark, depending on the lights and darks in your drawing. You can go over your drawing again with the pencils, but only after it is completely dry.

In addition to the wood-encased graphite pencils, you'll find various degrees of thin leads that fit into a mechanical pencil holder. You will also find ¼-inch leads that have a plastic or metal holder. They are great for sketching outdoors.

Cousins to the carpenter's pencil are two pieces of graphite that are not encased in wood. One is ¼ inch square, the other is ½ inch wide and ¼ inch thick; both are three inches long.

Finally, there are the woodless drawing pencils made of graphite with a protective coating. They can be sharpened for fine lines or flattened for broad strokes, and they are available in the soft *B* category.

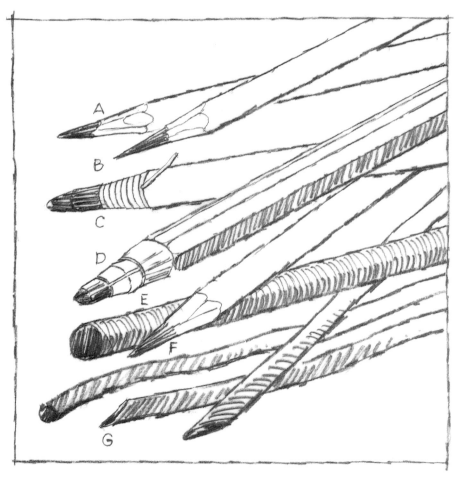

A spiral-bound sketch pad is very convenient, as you can tear a sheet out of the pad without fear of ruining your drawing. It also folds over nicely, but be sure to slip a piece of newsprint between each drawing so as not to smear them. Newsprint pads are economical and usually bound with glue, so the sheets are easily removed. Your sketchbook will see a lot of use, so I recommend the hard cover, because you are sure to produce some gems you will want to protect.

A. Charcoal pencil, hard
B. Charcoal pencil, soft
C. Wrapped charcoal pencil
D. Mechanical pencil for ¼-inch charcoal sticks
E. Carbon stick
F. Conté sketching pencil
G. Vine charcoal sticks

CHARCOAL

This wonderful medium can also be acquired in pencil form. The degree of softness will vary with the manufacturer. Another type of charcoal pencil comes wrapped in a paper casing that you peel to expose the charcoal. One of my favorites is a ¼-inch charcoal stick that fits into a metal or plastic holder — a wonderful sketching tool. You can also acquire sticks of compressed charcoal with carbon added. You get greater coverage and rich black from them. Then you have the natural vine charcoal, which is easy to apply and to blend. All forms are worth trying.

DRAWING PADS AND SKETCHBOOKS

Many fine papers are available today, but to get started, I recommend an 18″ × 24″ pad of Strathmore 400 Series Drawing Paper, regular surface. This is a good all-around paper with a nice surface that is accommodating to both pencil and charcoal.

Newsprint is an inexpensive type of paper (newspaper) that is excellent for formulating your ideas and working out problems without the fear that you are wasting good paper (14″ × 17″ or 18″ × 24″ rough will do nicely).

Your sketchbook should be at least 5½″ × 8½″ and hardcover rather than soft. This sketchbook should accompany you wherever you go. Get in the habit of sketching everything around you; it's a wonderful way to start training your eyes to see. Every sketch does not have to be a masterpiece, but wait till you see the difference from day one to the day you reach the last page.

DRAWING BOARD

Sometimes the sketch pad or paper you are working on will need some support under it. You can buy a drawing board in the art store or make your own out of a piece of Masonite or ½-inch plywood. If you use plywood, seal it with polyurethane—it will last longer. As you are working with 18″ × 24″ sheets of paper, your board should be at least one inch larger all around. You will find the surface of your drawing paper more accommodating to your pencil if you slip several sheets of newsprint underneath it.

NEWSPRINT PAPER

A drawing board will support your sketch pads or sheets of paper. Pictured at left is a board made of plywood and Masonite; either will do the job for you. You may have to give the board a light sanding before sealing it. Then tape down some undersheets of newsprint.

ERASERS

I am not one to encourage erasing and spoiling a beautiful piece of paper, since sketching outdoors gives you leeway to cover most of your preliminary lines. Several kinds of erasers will serve your purpose. A kneaded eraser can be squeezed and shaped to make a fine line or balled up to pick out highlights or to lighten dark areas. The new plastic erasers do a competent job of removing excess lines and general smudging. The old soap eraser is also good for cleaning large areas.

In selecting your erasers, pick one that will be kind to your paper. Too much scrubbing will have an adverse effect on your paper and can form a resist, preventing your pencil from working properly.

Erasers
A. The Art Gum or soap eraser is good for cleaning surface dirt from large areas.
B. Pink Pearl is another old-timer that has shaped ends for removing pencil marks.
C. A white plastic eraser will remove pencil marks without much effort.
D. A blue plastic eraser is for more stubborn pencil marks and grit, and it will not harm your paper. Both plastics do an excellent job.
E. The kneaded eraser is a must in anyone's equipment box. This eraser can be squeezed into any shape and is very good for lifting charcoal or pencil out of dark areas that you wish to lighten. Do not scrub with this eraser, as you will just embed the dirt into the paper.

SHARPENING PENCILS

I prefer single-edged razor blades for sharpening my pencils because I can expose more lead than with a sharpener. To sharpen with a blade, place the blade between your right thumb and forefinger as shown. Place the pencil in your left hand, and with your left thumb, push the blade forward into the wood of the pencil. Take short, shallow strokes at first. As you push the razor forward with your left thumb, the right hand turns the blade upward and away from the lead. Keep rotating the pencil, and repeat till you have the desired amount of lead exposed. Then take your sandpaper block and sharpen the lead to the shape you desire.

This procedure may feel strange at first, but after several pencils, you, too, will prefer this method over any other. After using the razor, store it safely. You don't want any loose blades rattling around in your pencil box. If you do not feel comfortable using a blade, acquire a small, portable pencil sharpener. For safety reasons, avoid double-edged blades. If you wish to use a knife, make sure it has a retractable blade.

Sandpaper Block

This is a piece of wood approximately seven inches long with a pad of sandpaper sheets stapled to one end of the piece of wood. Its main function is to sharpen your pencils and charcoal sticks after you have exposed your lead with the razor or knife. If you find yourself in the woods or fields and suddenly realize that you forgot this handy piece of equipment, look for a flat rock—it will save your day.

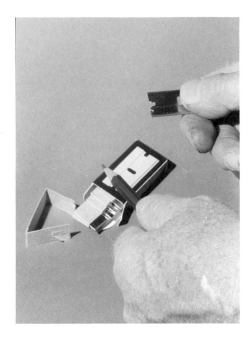

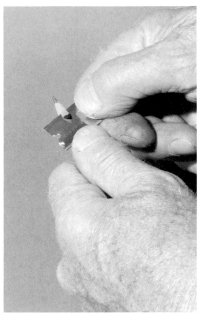

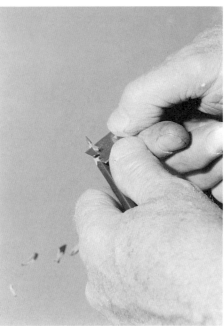

Sharpening
Following the procedure illustrated above, try sharpening a few pencils. You will be able to expose more lead than with a pencil sharpener.

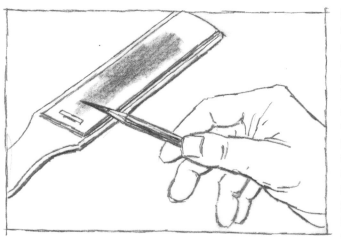

Sandpaper Block
One word of caution while using the sandpaper block: Do not press down too hard while making a point, as you can snap the lead very easily. Applying a minimum of pressure while rotating the pencil works nicely.

STOMPS AND TORTILLIONS

A stomp is made of a felt-like paper pointed on both ends resembling a cigar. It is primarily used for blending tones. You can clean and reshape the points by rubbing the stomp on your sandpaper block.

Tortillions are used for the same purpose, except that they are smaller and have a point on one end only, which is good for getting into small areas. Ordinary soft facial tissues may be used for blending large areas and to remove an area for reworking.

OUTDOOR EQUIPMENT

Pack stools come with a backrest or without; the choice is yours. Look for the stools that have a couple of pockets plus zippered compartments on both sides, which are excellent for storage. A small folding chair is fine, but I recommend the pack stool because of the pockets, which give you extra storage space, and the shoulder strap, which makes carrying a lot easier.

Easels come in an assortment of shapes and sizes. I use one of two different styles, determined by the circumstances. If I will be walking any distance, I'll use my lightweight, wooden folding easel. The other is a French easel, which was a wonderful gift from a group of former students. It's a very convenient piece of equipment.

Before you purchase your easel, look them over carefully. Talk with your fellow artists; see if what they are using will meet your requirements. Ask them if their particular easel is sturdy, as well as easy to carry and set up. Don't be bashful: You want to acquire the easel that will be most

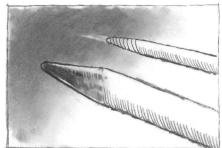

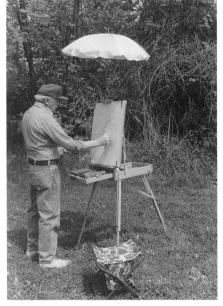

French Easel
Here is my French easel extended with an umbrella attached. The top can lay flat if I want a table-like surface, or if I want to sit, the legs can be adjusted. My pack stool is nearby with some extras in the pockets.

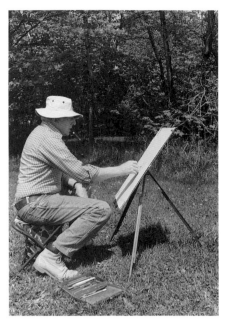

Stomps and Tortillions
These are great tools for creating soft tones and for blending in small areas. A clean stomp or tortillion can also be used to remove some tone.

Folding Wood Easel
This is lightweight and folds to a convenient carrying size. I suggest periodically checking the nuts and bolts that hold your easel rigid. This will prevent losing them in the field, where they will be hard to find.

practical for you to use.

The French easle comes in several styles, including one called a *backpacker's easel*, which has straps so you can carry it on your back. This frees your hands for carrying other equipment. Another style of French easel comes with two different-sized boxes. The narrower box is about 12 inches wide, and the wider is 16 inches. This easel can be used whether you sit or stand, and you can put your pencils and quite a few other items, including paints or pastels, in the box.

Many other types of easels are available. Check them out. The goal is to make everything compact, simple and easy to transport.

An umbrella is not an absolute necessity, but more times than not, you will find yourself working in the sun wishing you had one. The umbrella keeps the glare of the sun from reflecting off your paper, which will enable you to capture the true values of the picture before you. A C-clamp attaches the umbrella to your easel, and a gooseneck allows you to adjust for different positions.

PAPERS

I once read about an artist who, before starting to work, would find himself running his hand over the sheet of paper in a sort of caress, marveling at the beauty of this piece of paper. At first I thought it was the author embellishing the story, but one day, sitting out in the field about to start a drawing, I found myself running my hand over the surface of my paper. Now I am not saying you should run your hand over every piece of paper you are about to work on. What I am saying is that you will discover for yourself the wonder of paper, the many different surfaces that are available to experiment with, and how the various textures will react to your pencil or charcoal.

Paper is made three different ways: handmade, mould-made and machine-made. As the name suggests, each sheet of handmade paper is individually made by hand. No two sheets will be exactly the same. Many beautiful papers are produced by this method. One way to recognize a handmade sheet is by the natural deckles it will have on all four sides of the paper. Today, many individual shops produce handmade papers. If you know of someone in your area making paper, call and ask if you can watch the operation. It will be a wonderful experience, and perhaps you will see a sheet you might like to try.

Mould-made paper looks like handmade paper, but it is made with a cylinder-mould machine that rotates at a very low speed, duplicating all the processes of handmade paper and allowing for quality control. This method also enables editions of paper to be made, even to reproducing the deckles, with one difference. On a handmade sheet, the deckles will be uneven, whereas a mould-made piece will have more of a uniform deckle. Some of the best-known names in paper, like Arches, Fabriano and Whatman, to name a few, produce great papers with this process. This means artists have available a wide selection of good paper with a handmade look at a reasonable price.

Machine-made papers are made by a fast-moving machine that does everything from pulp to finished sheet—even simulating texture—all on one machine. Sheets of paper made by this method are uniform and have no deckle. Many fine companies like Strathmore and Canson produce excellent machine-made paper, providing the artist with yet another category of reasonably priced, high-quality papers.

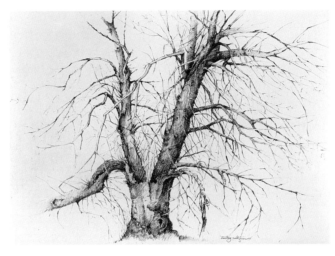

Handmade Paper
The Gladiator
23″ × 31″
Charcoal drawing on a piece of Misumi, a handmade Japanese paper.

Each sheet is a little different, but all have very receptive surfaces for soft charcoal and soft lead. I used a combination of pencil and ¼-inch charcoal leads.

Mould-Made Paper
The End of Fall, 19½″ × 27½″, charcoal sketch on a sheet of Fabriano Ingres cover.

This mould-made Italian paper with a laid texture has an excellent surface for charcoal and pencil. I used one side of a ¼-inch charcoal lead to create a chisel-like surface, which left me a sharp edge for fine lines.

HOW PAPER AFFECTS DRAWING

Paper comes in a great variety of surfaces. Your choice of surface will be an important element in the outcome of your drawing. You should also consider what medium you are going to use—pencil or charcoal—in conjunction with your choice of paper.

A *rough* surface would accept charcoal more readily than pencil. Charcoal would fill the valleys or "tooth" of the paper without much trouble.

A *laid* paper gives you an interesting surface of lines running vertically and horizontally; it works well with both pencil and charcoal. Drawings on laid paper reproduce well because of the screen effect.

A *vellum* with slight texture accepts pencil as well as charcoal, and it gives the finished piece a nice sparkle.

A *hot-press* paper (smooth) without any tooth would work well with pencil, enabling you to get more detail than with a charcoal pencil.

You have many choices to experiment with, and that's what you should do. Experiment, have fun, make notes; write down the name of the paper you use, as well as your comments on the reaction of your medium on that particular paper.

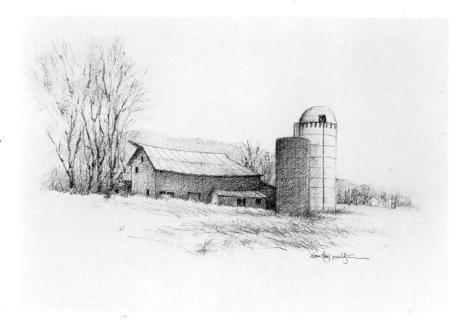

Rough Paper
Claverack Barn is a charcoal drawing on Gutenberg stock. This paper's rough surface lent a nice sparkle to the drawing and helped me capture the feeling of being out in the open field.

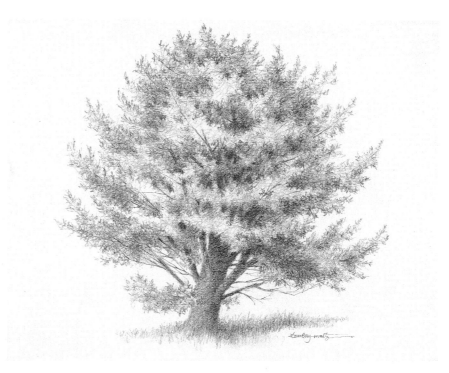

Laid Paper
White Pine is a charcoal drawing on Fabriano Ingres cover heavyweight stock. Again, I wanted an airy look to this study, which the Ingres paper gave.

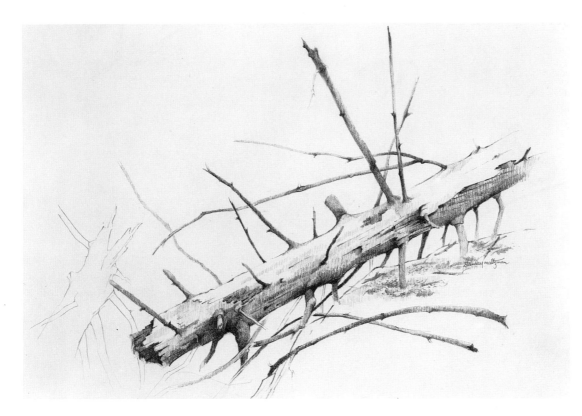

Vellum
For *Fallen Pine Study*, I was interested in capturing more detail, so I chose a paper with less texture: Strathmore bristol.

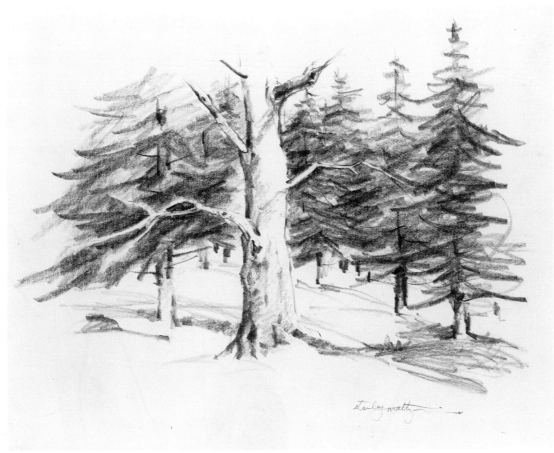

Hot-Press Paper
Winter Tree Study was an experiment to see if the paper would help me capture the quiet of the woods with snow on the ground. A piece of Arches hot-press watercolor paper with a smooth surface provided the feeling I was looking for.

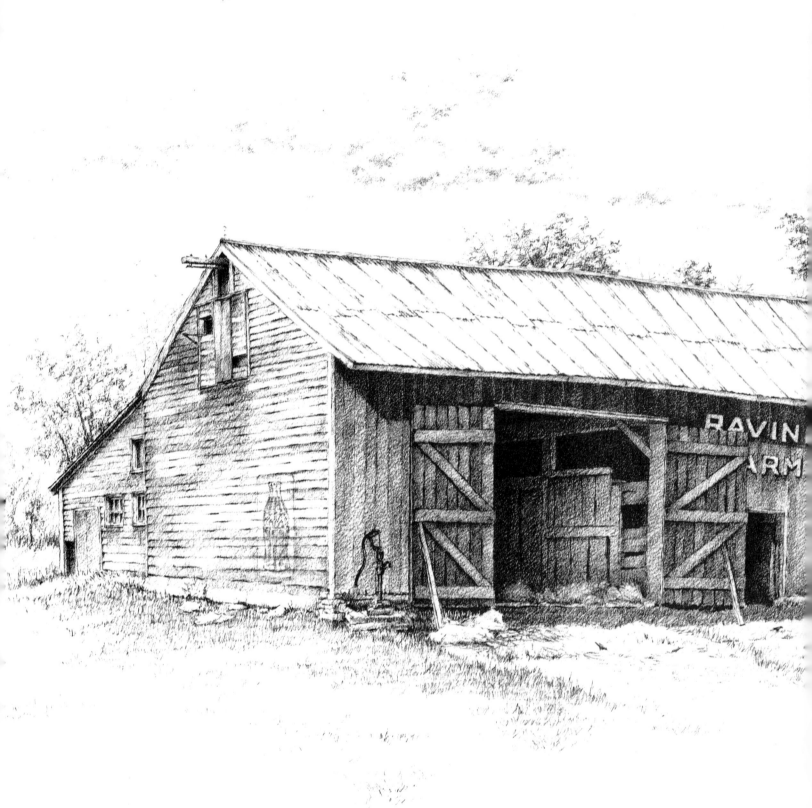

Ravine Farm, 21″ × 29″, charcoal pencils on handmade Japanese (Goyu) paper.

Getting the Most From Your Pencil

In the following pages, we will look at several different techniques and methods to get you started drawing nature outdoors. Learning to see the many picture opportunities available before you and to choose your subject is part of the challenge of outdoor drawing. Though many of the techniques may be new to you, they will soon become second nature as you begin, with each new outing, to see and capture your discoveries on paper. These are not the only ways to draw, but they are sound steps with which to begin.

CHOOSING YOUR SUBJECT

Something has attracted your attention. Something has caused you to stop and take a second look. Perhaps it is a gnarly old tree, or a group of trees silhouetted against a mountain, or clouds reflected in a stream. It doesn't matter exactly what it is—what matters is that it has started your creative juices flowing. Walk around, get as close as possible; there's no hurry. Study the scene; get the feel of the area; try to become a part of the landscape.

At right are three photos of a landscape that attracted my atten-

tion. The problem with such a vast landscape was what to include in my drawing and what to leave out. With a viewfinder I was able to concentrate on only what I felt would make an interesting drawing. Of course, I rearranged and eliminated some of the landscape, but that is my privilege as an artist. More important, it is the creative process at work. The drawing below shows what I chose to include from the three landscape photos. I also added an element from my own imagination—the old fence posts.

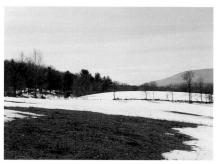

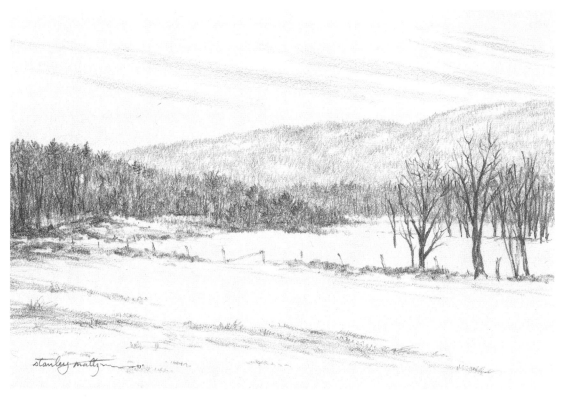

From My Studio, 5″ × 8″, graphite pencil on Strathmore Alexis paper.

USING A VIEWFINDER

At one time or another, we have all looked through that little window in our camera to see what would be in the picture. That window is called the *viewfinder*. But holding a camera up to your eye can become awkward and tiring. You can easily make your own viewfinder by taking a 3″ × 5″ index card or any piece of stiff board, and cutting an opening 2″ × 3″. It's that simple. At right, you see one style of cardboard viewfinder with three different-sized openings. Adding an additional piece of board with a paper clip will enable you to adjust your viewfinder to a square and even vertical opening. Holding the viewfinder farther away shows a distant view and gives you a smaller portion of the landscape. Moving the viewfinder closer will give you a broader scope of the same view.

Below, you can see how to adapt your hands to form a viewfinder. (You will be less likely to leave these at home!) With a little practice, using a viewfinder will become second nature, and in time you will train your eye to do the job of the viewer. However, don't expect to find the perfect picture to copy. Use the scene that stimulated your interest, and develop it into your drawing.

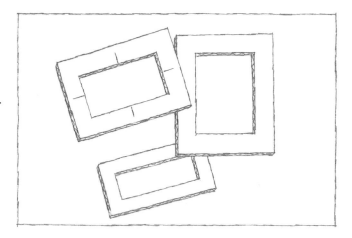

Here are three cardboard viewfinders with different-sized openings.

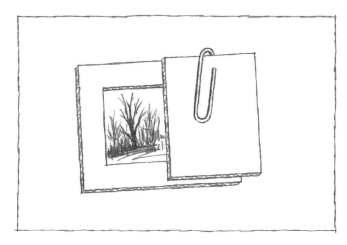

With another piece of cardboard and a paper clip, you can adjust the opening.

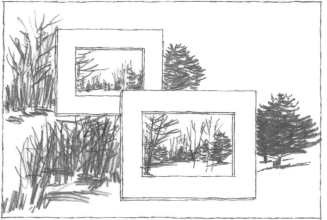

The closer you hold your viewfinder to your eye, the broader the scope of the view.

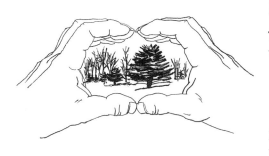

In a pinch, just use your hands as a viewfinder.

THE PROPER WAY TO HOLD A PENCIL

The way you hold your pencil (or any drawing tool) will affect the outcome of your work. Holding it as you would if you were writing (see photo at top) is good for detailed or controlled work, as you are primarily moving only your fingers and wrist.

On the other hand, when sketching and drawing outdoors, you'll want more freedom. Try to move not only your wrist, but the whole arm, giving the mobility and the sweep needed for working on large sheets of paper. The bottom photo shows how to hold your pencil to get your whole arm in motion.

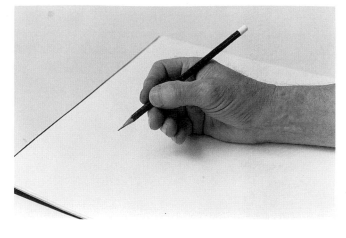

Holding your pencil in this manner is ideal for doing detailed drawings and small works.

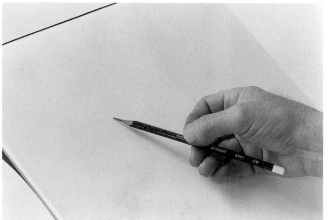

Hold your pencil like this when sketching or drawing outdoors. This position gives you more freedom, enabling you to move your whole arm.

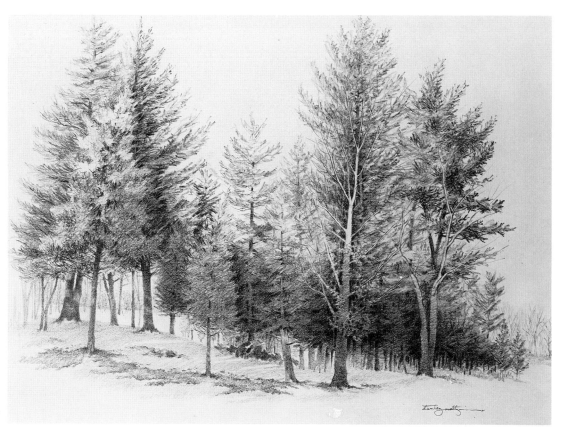

Stand of Pines
18″ × 22″
Charcoal pencils on Whatman paper. Collection of John and Judy Jester.

I started this drawing by holding the charcoal pencils in the manner for doing quick sketching. About two-thirds from finishing, I changed my position—holding the pencil for tightly detailed work.

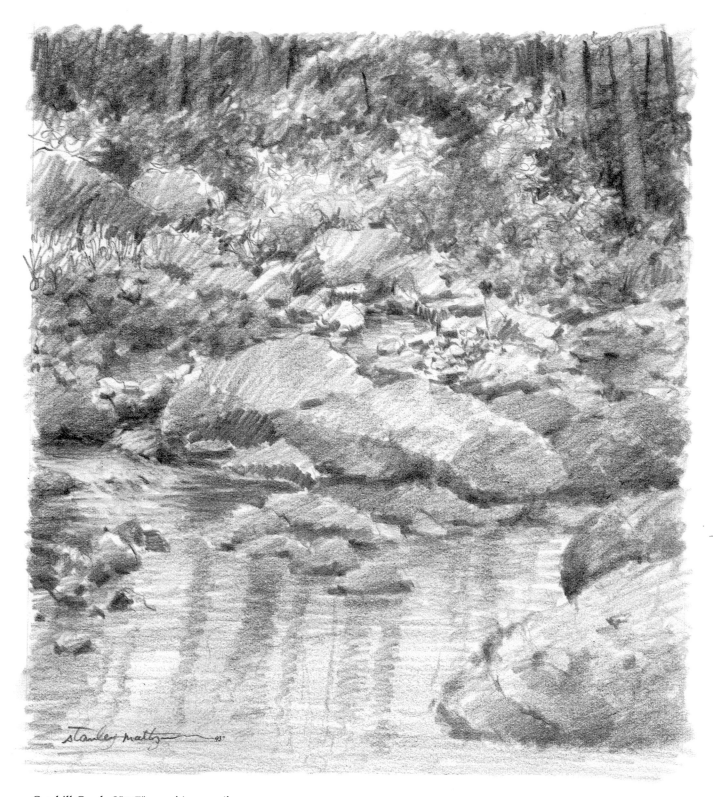

Catskill Creek, 8″ × 7″, graphite pencil.

This drawing was executed holding the pencil for quick sketching. What caught my eye was the pattern of darks and lights in the woods and on the rocks with the reflections in the water. It did not take me long to realize that I had a bonanza of material for future drawings.

PENCIL VALUES

Value refers to the range of lights and darks your pencil can produce, from a dark black to a light gray and all the shades in between. Experiment with various types of pencils to discover what values they produce. Observe which lead will give you the richest black, and which a nice gray. You don't have to memorize everything a particular pencil will accomplish: Just get a good working sense of the range of pencil values.

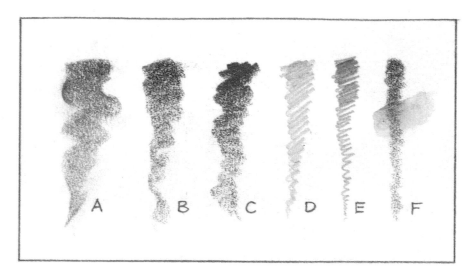

These values were created by the following pencils:

A. Carpenter's pencil, 4B lead
B. ¼-inch graphite lead, no. 2, in a mechanical pencil
C. Woodless pencil, 6B
D. Mechanical pencil, 2H lead
E. Wood encased graphite pencil, H
F. Water-soluble pencil, very soft

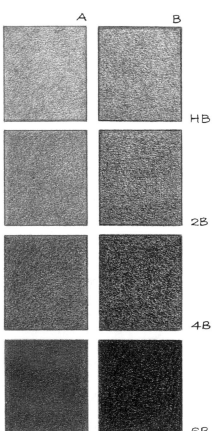

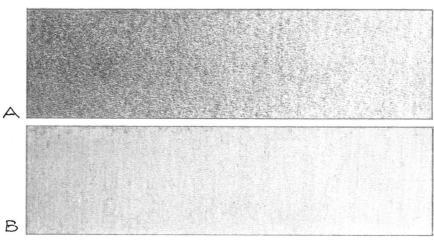

Row *A* is a 2B graphite pencil. Row *B* is a 2H graphite pencil. Notice the difference in richness.

Column *A* is graphite. Column *B* is charcoal. Even though they are the same pencil numbers, notice the slight difference in the values.

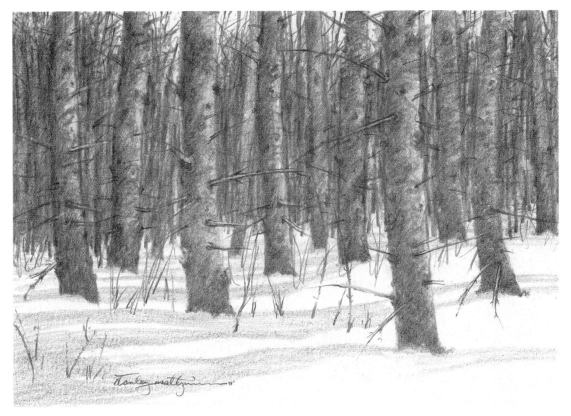

Winter Woods
5½″ × 8″
Graphite pencil.

This drawing was created using one pencil, an ebony jet-black graphite pencil, which enabled me to hold my values fairly close, giving the impression of a densely wooded area.

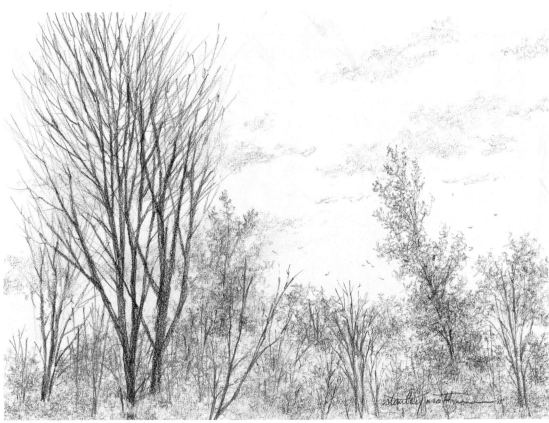

Autumn Trees
7¼″ × 5½″
Charcoal on Strathmore Alexis.

In this drawing, I used several different charcoal pencils to capture the many values of autumn colors. I used HB general charcoal for the lightest trees, B charcoal for the darker foliage, and 2B for the smaller trees without foliage. Last, I used a 4B for the darkest bare-branched maple.

SHADING METHODS

Your pencils can help you create many varied lines and textures: thick or thin lines, hard or soft lines, and any manner of shading. The methods you use to achieve them are called *technique*. With work and time, these techniques evolve into your own *style*. Try the following methods of shading with different papers and pencils. The key is to experiment; remember that mistakes help us to learn.

Circular Shading

As seen in the illustration (above right), this method starts at the right side with small, circular shapes. As you continue shading toward the left, the circles merge and disappear into a beautiful, rich tone. I use this type of shading to render intricate studies like the drawing below. It is a type of eye exercise that can help you see the landscape as shapes of lights and darks.

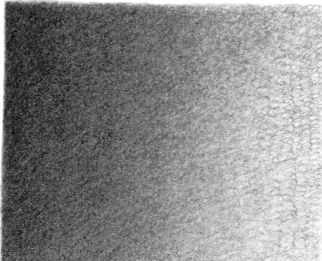

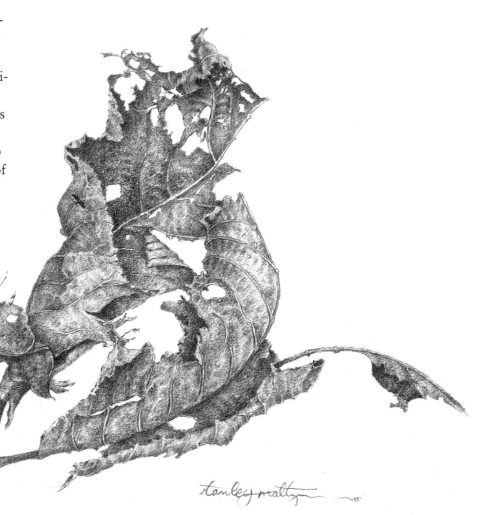

Yesterday, 5½" × 8", carbon pencil on Whatman paper.

Angular Buildup

These sketches of a tree and fence show two ways of rendering a subject with angular lines. In the sketch at left, the pencil is held in the position for sketching outdoors. As you build the tone, the preliminary lines disappear, and your darks and lights emerge—an excellent method for outdoor sketching. The righthand sketch is a more decorative type of angular rendering, but one must be careful not to let the line pattern distract from the picture.

The drawing below was created using the angular buildup. Not much was added to the preliminary shading in the background tree. You can see that the shading was carried further to build up the darks of the bark in the tree in front.

Angular Buildup

Tentacles, 23″ × 31″, charcoal. Collection of Mr. and Mrs. George Schiele.

This drawing was executed with a ¼-inch charcoal stick in a mechanical pencil. The pine needles were rendered with a B charcoal pencil.

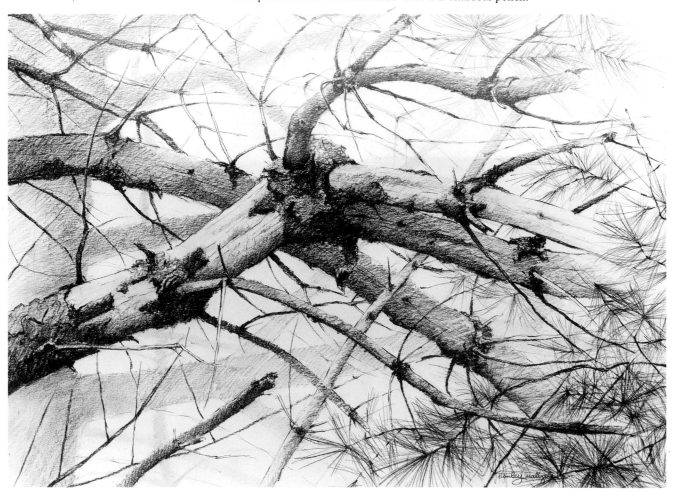

CROSS-HATCHING

Cross-hatching is a technique that uses a series of parallel lines running in different directions. Box *A* of the illustrations shows the starting process. Note that all the diagonal lines are parallel to each other. Box *B* shows the addition of vertical lines. Notice that with just the vertical set of lines added, the value has deepened. The lower-right corner is made darker by increasing the pressure at the bottom of some of the strokes. With the addition of more diagonal and horizontal lines, the box continually becomes darker till you reach the value you desire.

Cross-hatching is a process more suited to pen and ink because of the many fine lines, but with planning and patience, it can be done with a graphite pencil.

Boxes *E* and *F* show examples of cross-hatching methods. The drawing below, done with an HB general graphite pencil, demonstrates the cross-hatching technique.

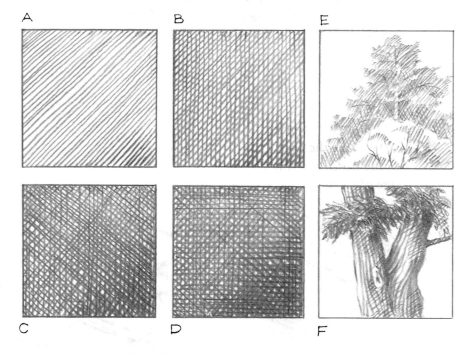

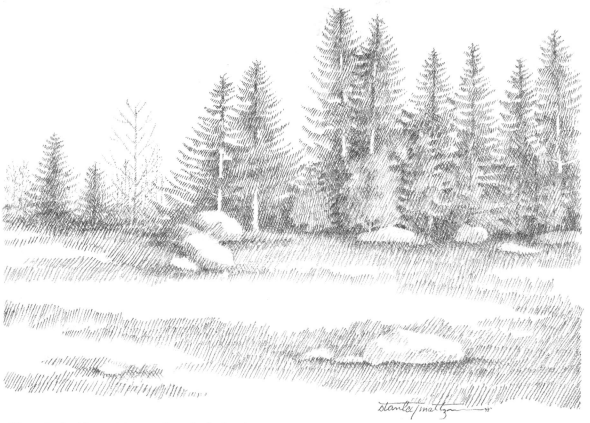

Pines, 5½" × 8", graphite pencil on 2-ply Strathmore.

DRAWING NATURE

CARPENTER'S PENCIL

The carpenter's pencil is another wonderful sketching tool to use in conjunction with the regular pencils. As seen in these sketches, values are indicated with simple, broad strokes. Add darks by pressing the lead harder. I added a Derwent carpenter's pencil (4B) to the second sketch (far right) for additional blacks.

For drawings with heavy foliage, such as the one below, use the same technique with more modeling. To make the finer lines, hold the pencil sideways, using the edge of the lead.

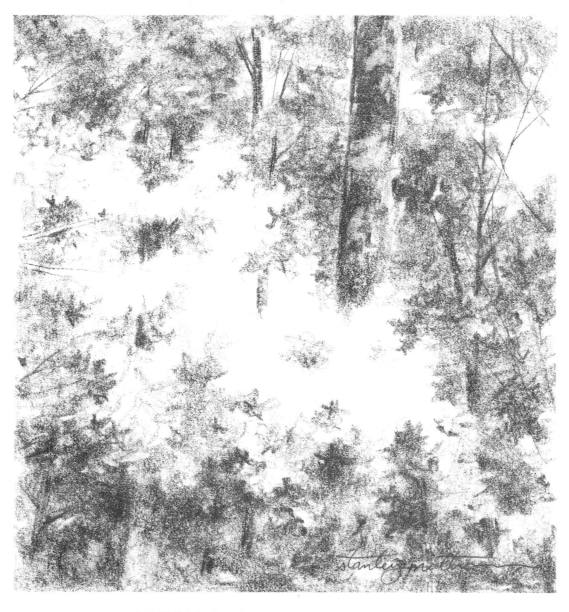

Hunter Mountain Foliage
6½" × 6"
Carpenter's pencil.

BLENDING WITH STOMPS AND TORTILLIONS

These cigar-shaped blending tools are great to work with. I have salvaged quite a few drawings with their help. The drawings on these two pages demonstrate some of the numerous ways to work with stomps and tortillions.

The drawing at top was executed mostly with a chamois stomp. I put some charcoal powder on a separate piece of paper (I save the powder from charcoal pencil sharpenings), then rolled part of the point of the stomp in the powder, and rubbed it lightly on a piece of scrap paper so it wouldn't be too strong in value. I put the distant mountains in first, then the large dark mass of trees. With what was left on my stomp, I modeled the field. I rolled it again in the charcoal powder to get darks in the foreground and the clouds. I took a clean tortillion and a kneaded eraser and removed some of the tone in the upper left corner and at the baseline of the trees. I then added a very gentle touch of 2B charcoal pencil along the tree line and the base—just enough to finish the drawing.

The middle drawing was first sketched with a 4B charcoal pencil. Using the leftover charcoal from the drawing, I modeled the rocks with a small tortillion, adding darks and emphasis where needed. The water was modeled with a large stomp, then a few light lines with an HB charcoal pencil completed it.

In the bottom drawing, I covered the whole background with one value of charcoal, then came back with additional darks, building up the tree mass. With an HB charcoal pencil, I added just a lit-

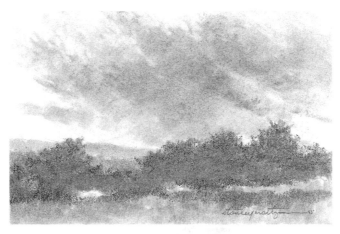

Evening Clouds
3″ × 4½″
Charcoal on Strathmore 2-ply bristol.

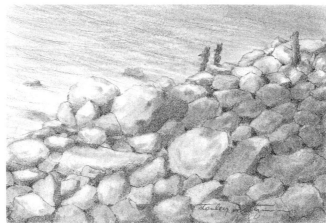

Along the Hud-son
3″ × 4½″
Charcoal on Strathmore 2-ply bristol.

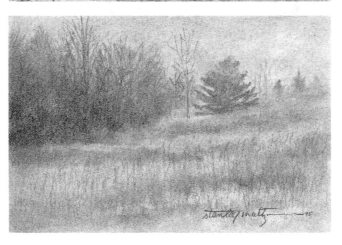

Evening Fog
3″ × 4½″
Charcoal on Strathmore 2-ply bristol.

tle more suggestion of trees to give the effect I desired.

The large drawing on the opposite page was stomped with charcoal powder first, then I modeled the trees and foliage on top of the stomping with a charcoal pencil. When using a stomp, avoid scrubbing the paper too hard, as it will cause the charcoal already laid down to be less pliable.

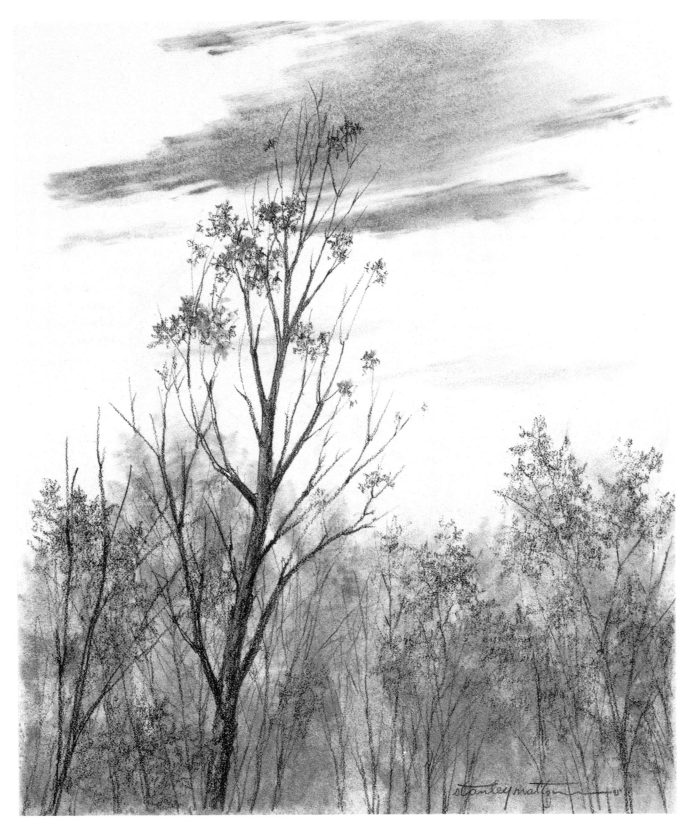

Season's End, 8¼″ × 6¾″, charcoal on Strathmore 2-ply bristol.

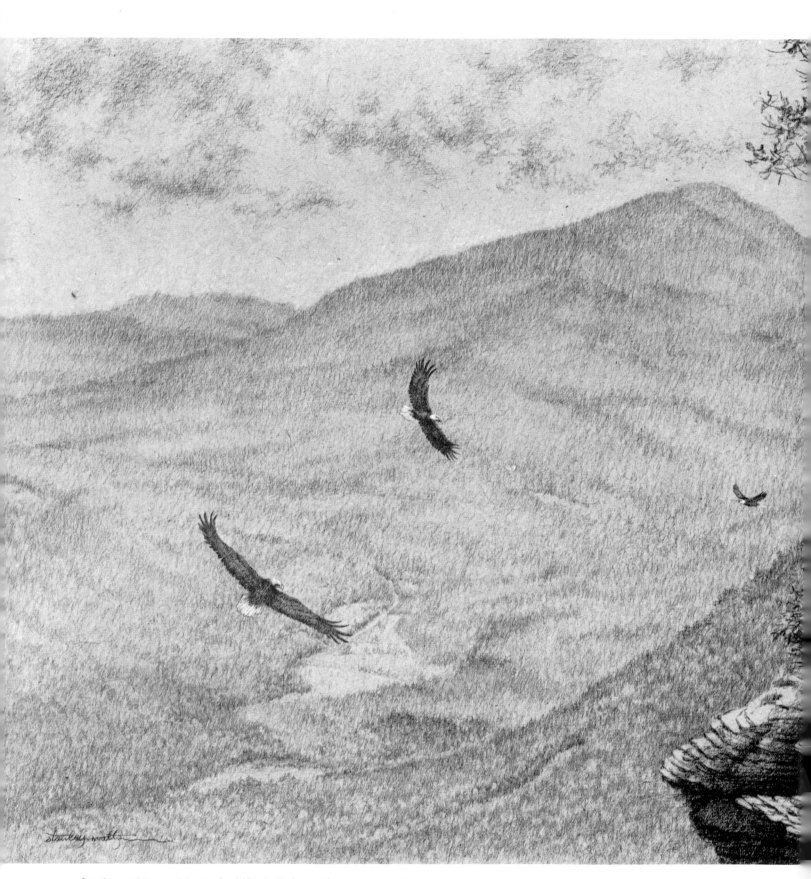

Soaring at Hunter Mountain, 22″×31″, charcoal on Japanese (Misumi) paper.

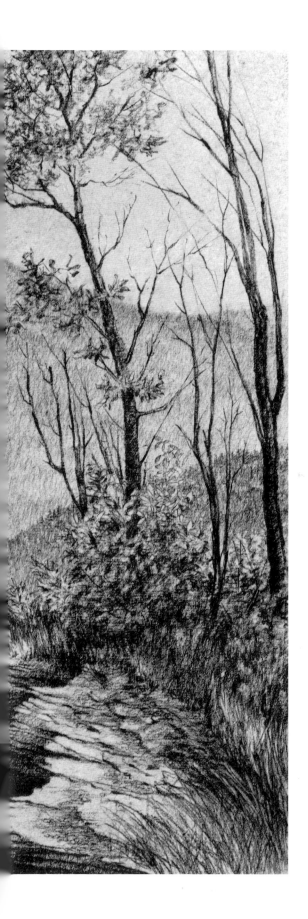

Composing Your Picture

Every picture must have a focal point where the artist places the most interesting shapes and elements to create the center of interest. To start the thinking process, we must first consider the composition. The dictionary says: "Composition is the art of combining parts or elements to form a whole."

Let's say you have found an area that you wish to develop into a picture. Start with visual thinking—putting your thoughts about what you see and feel down on paper. Decide on either a horizontal or vertical format. Make some rough sketches of what you want your picture to look like. This is visual thinking: You are developing your composition, creating a center of interest by balancing the elements, moving or eliminating objects, deciding your values, and trying various combinations of foreground, middle ground and background.

Your sketches can be only as suggestive as you wish. Their main purpose is to arrive at a good working composition. Besides, they are fun to do!

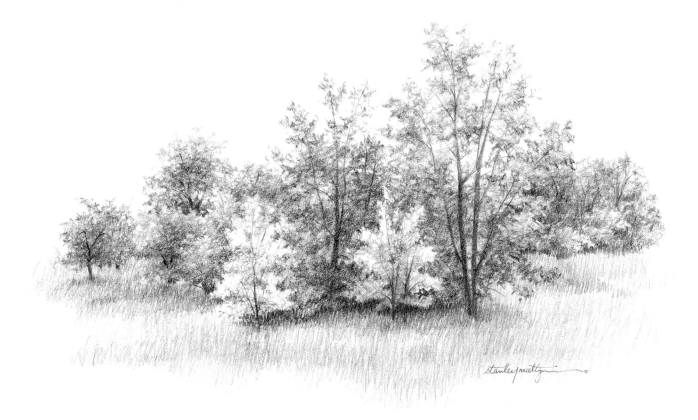

DECIDE ON A FORMAT

Deciding on a format is not diffi-
cult. More often than not, the
landscape or subject will dictate a
horizontal or vertical format to
you. Try the standard sizes, like
9″ × 12″ or 12″ × 16″, or get cre-
ative and try a 16″ × 6″ vertical.
Start by taking your newsprint
pad and making thumbnail
sketches. Try various formats;
you don't have to decide on your
first sketch. Most likely one
sketch or idea will lead to an-
other. Then decide on the most
pleasing format and develop your
landscape to the format you have
selected.

Horizontal Format
I was drawn to the horizontal format to depict this array of trees and bushes
because of the way they were growing. I used my thumbnail sketches and
viewfinder to help me make a selection.

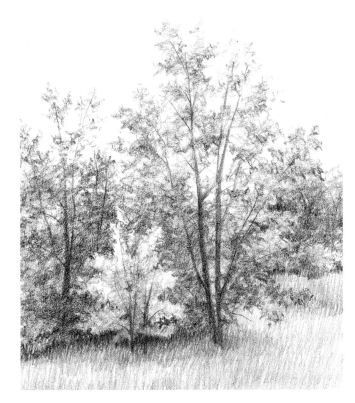

Vertical Format
Within the above
grouping of trees,
I found an interest-
ing composition
for a vertical for-
mat. I cut a verti-
cal opening out of
a piece of bond pa-
per, then placed it
over the horizon-
tal drawing, mov-
ing it about till I
came up with this
pleasing vertical
sketch.

DECIDE ON A STYLE

Deciding on a style of execution of your drawing will depend on how far you intend to carry the extent of finish of the drawing, and what you are interpreting. Do you intend to make a complete picture touching all four sides? Do you want to do an outline or contour drawing of a rock or leaf? Or do you wish to create a designed drawing to fit a specific shape like a vignette? The drawings on this and the following two pages show two different styles of execution: a contour drawing and a vignette.

Contour Drawing

A *contour drawing* is simply an outline of a subject, and it's an excellent way to sharpen your eye and your memory. You will find with a little practice that you can make beautiful contour drawings by varying the thickness of your pencil line as you draw, that is, by applying pressure for a heavier line, as in a shaded area, and easing up when you desire a thin line.

The large drawing (right) is a *controlled* contour, where I looked at both the tree and my paper. This helped me understand the makeup of this tree. The small insert was drawn while looking at the tree, but not at the paper, a good memory exercise. Another wonderful exercise in contour drawing is to study the subject for a minute or two, then draw from memory. Do not look at the subject again till you are finished. You will be surprised in time, as you practice these exercises, how close your drawings will come to the subject, and how your eye will start to pick out details you never noticed before.

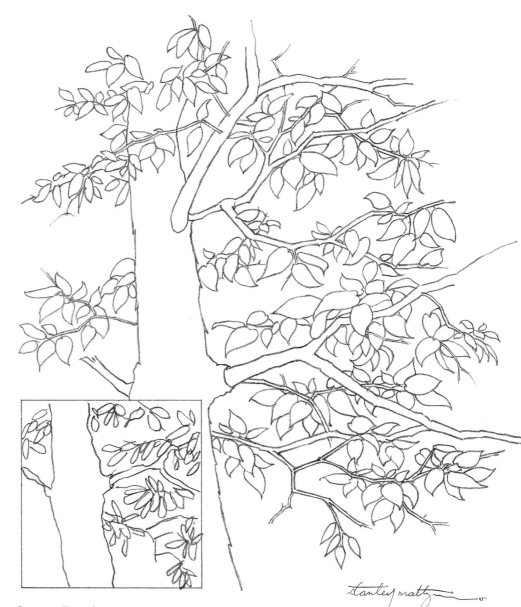

Contour Drawing

By the time I finished this contour drawing, I had thorough knowledge of this tree. I drew the small insert area by looking at the tree but not at the paper, whereas for the large drawing, I looked at the tree *and* the paper.

Vignette

A *vignette* is a drawing or a design without four straight borders. It may have a partial border, such as the small drawing below. Notice how light the shading on the left is, leading you to the top of the trees and mountain, which is dark enough to hold the edge. On the right, I created a border with the curve of the grass, which leads your eye back to the left.

The vignette at right suggests a drawing that does touch all four sides of a rectangle, but as you can see, it is the shape that gives that illusion. There is no square edge to any side. Drawing a pleasant, balanced arrangement without four borders makes a successful vignette.

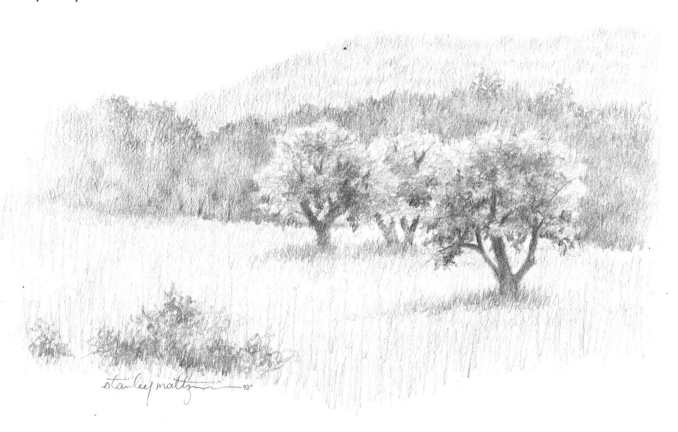

Vignette

The beauty of working with a vignette is that it gives you an extra incentive to design with shapes. Your picture will not have four straight edges to hold it together. You may include an edge or border if you desire, and you can also shade the edge of your drawing by gradating the values from dark to nearly invisible.

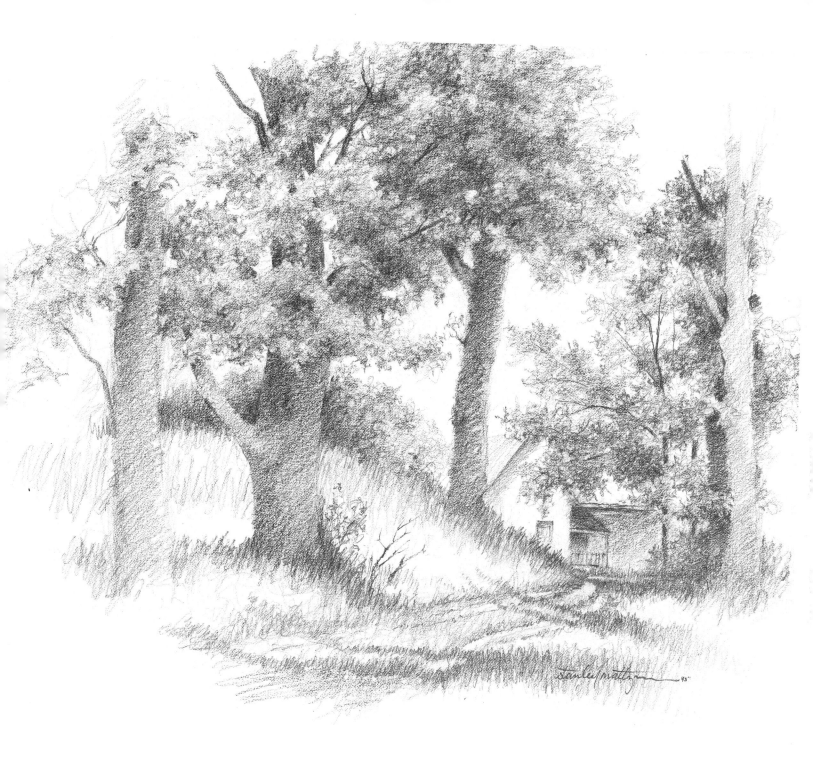

Down the Road, 11″ × 14″, graphite pencil on Strathmore 2-ply bristol.

THUMBNAILS

Thumbnails are a wonderful way to get your creative energies charged up. This is the time to work out your picture—now, before you start the finished drawing. Your key thought should be to *simplify*. Remember, you are only looking for ideas. Don't get involved with details at this stage, and keep your thumbnails small—postcard-sized or smaller. Build your composition by including interesting shapes, determining your values, and deciding on your center of interest. Do you want a low horizon or a high horizon? That tree looks like it is growing out of the roof of the house: Move it. You can move, eliminate or add whatever elements will help make your picture. This is the purpose of thumbnails, getting your ideas down on paper where you can see them. You will find that one idea will lead to another and before you realize it, you will have a sheet full of ideas. Pick out what you feel is your best thumbnail, or combine the best ideas from a few sketches.

Arrange all your ideas into one thumbnail, which will become your working sketch. You may want to enlarge it to help you see things more clearly. Go right ahead—working out all the problems now will make your final drawing easier and more fun to do. Save your thumbnails: They can become an excellent reference file, and some of the beauty you have captured in these quick little sketches will inspire you to create other drawings.

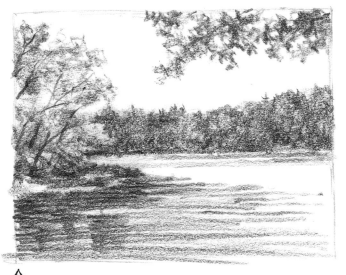

I started with a horizontal format showing a small shoreline on the left and a large tree line across the lake. The composition looked a little unbalanced, so I added the overhead branch. Not too bad, but the left side bothered me: Something was missing.

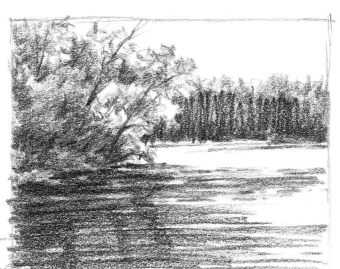

I decided to include more shoreline, and the trees hanging over the water created interesting reflections. I raised the horizon line and brought the trees across the lake in closer. Notice how quickly your sketch can change by moving your elements around.

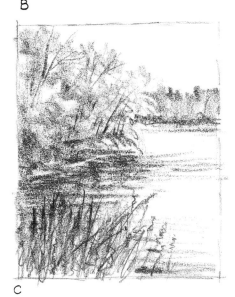

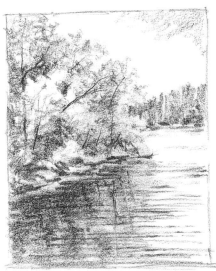

Then I tried a vertical format and added the weeds and cattails, which led me to try another design.

Finally, I felt I had successfully put the right elements together to make an interesting composition.

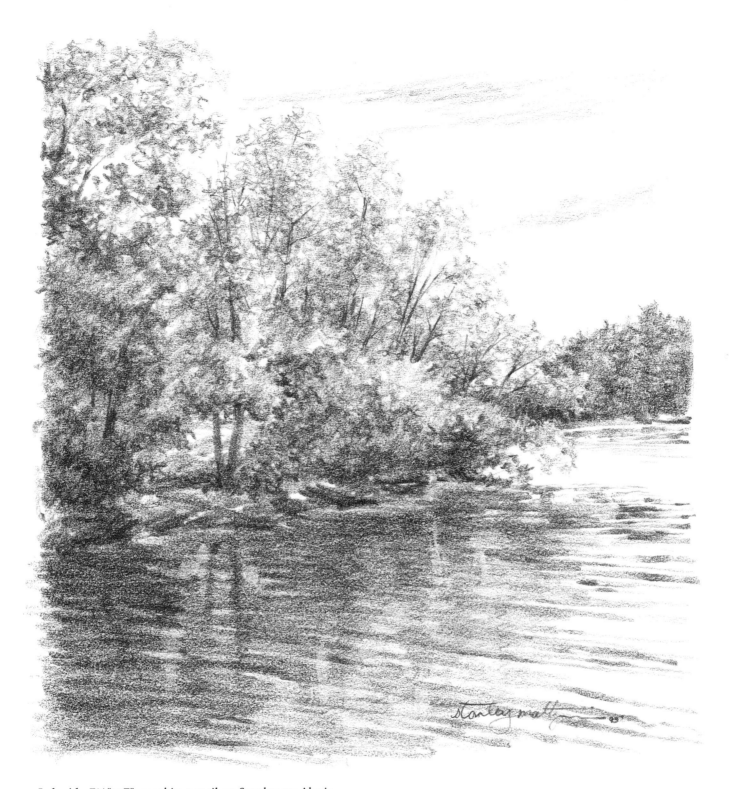

Lakeside, 7½″ × 7″, graphite pencil on Strathmore Alexis.

Here is the finished drawing composed from the thumbnails on the previous page. By changing to a slightly vertical format, I was able to include more of the shoreline with a greater variety of tree shapes. The reflections and darks in the water created interesting patterns of design. The trees in the background are there to carry your eye back to the left.

BALANCING ELEMENTS

No matter how many beautiful elements you have in your picture and how wonderfully the paint or pencil is applied, it will never be successful if the elements are not in harmony with one another—negative spaces balancing positive spaces, placing the horizon line above or below the center of your paper, etc.

In drawing *A* below, you see some common mistakes you should avoid. The horizon line divides the picture exactly in half. The large pine tree and the background trees are uninteresting because of their look-alike shapes, as are the two trees in the foreground. The road in the center leads your eye directly to the barn. Each element is centered and balanced with equal shapes that create boredom.

Sketch *B* has taken the same elements and created interest by lowering the horizon line and changing the shape of the forest. Mountains were added to give the drawing more depth. The large pine was moved to the right and is counterbalanced by the foreground trees on the left, providing a good example of a large mass and a smaller one creating a balance of elements. The curving road takes your eye to the barns, and though they are partially hidden, they are the center of interest. An object does not have to be overbearing to be the center of interest—the more subtle, the more interesting.

Drawing *C* is divided horizontally into three equally dominant parts: the foreground, the trees and the sky. The pine trees are the same height and character, guarding the edges. The road leads your eye to the woods, but not to any center of interest.

Drawing *D* also has horizontal divisions, but each one is a different shape and weight. The apple trees in the foreground are silhouetted against the pine woods, making them stand out and become the center of interest. Your eye focuses on the apple trees, then moves to the left because of the perspective in the trees. You follow the trees and mountain up to the clouds, then back to the mountain and the trees on the right. The elements are in harmony; thus, you have a pleasing sketch.

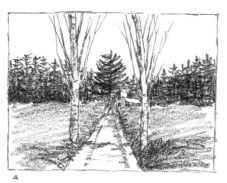

A

Mistake

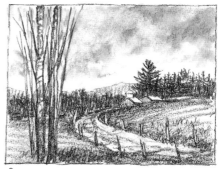

B

Improvement

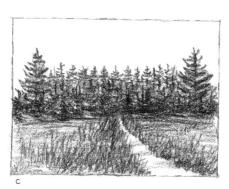

C

Mistake

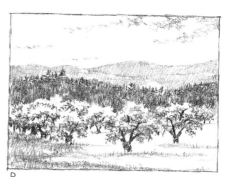

D

Improvement

DRAWING NATURE

HIGH HORIZON

As we saw on the previous page, a horizon line that cuts right across the middle of your picture can lead to a static, boring composition. Strive for unequal divisions and asymmetrical placement of the various elements in your drawing, which you balance with size, values or perspective. In this sketch, a high horizon line gives you the opportunity to produce a more interesting picture. The trail on the right is balanced by the field and dark area on the left. The trees lead you to the vanishing point, which is the center of interest, and to where the trail disappears beyond the tree line. The mountain was added to suggest that something is going on beyond the tree line. A little mystery creates more interest.

Using a high horizon gives you the opportunity to do more with the foreground; for example, you could create a large tree up front to add more depth to the picture.

LOW HORIZON

A low horizon line gives you the room to develop wonderful skies, to do something interesting with dramatic cumulus clouds or cirrus clouds flying across the vast space. Notice in this sketch that I also included more of the mountain. Remember that as you shift your working position from sitting to standing, the horizon line will also change.

Don't always place your horizon line in the same area on your paper. Just as your point of view changes as you shift your position, so should your horizon line move up or down depending on which elements you want to emphasize in your drawing.

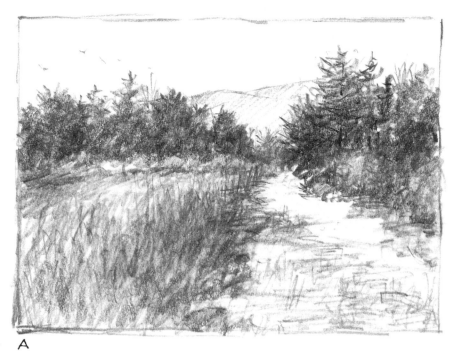

A

High Horizon
Using a high horizon line is another way to make an interesting composition; it also allows you to place many more elements in the foreground. Here, the trail on the right is balanced by the field on the left. The trees lead you to the center of interest where the trail disappears beyond the tree line.

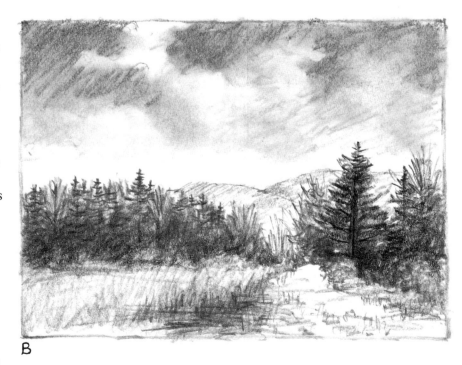

B

Low Horizon
The beauty of using a low horizon is that it leaves you room to work with dramatic skies and clouds, which is always great fun. It also lets you include many details in the middle ground, while giving the impression of vast distances.

SEEING VALUES

Values play a dominant role in the harmony and design of your composition. A large, dark area in the foreground can be balanced by a properly placed, small, dark area in the distance. Value contrasts can create your center of interest simply by having a light area surrounded by a dark area, or vice versa.

Seeing values correctly will help you to interpret the atmosphere and the colors of nature — the greens and blues, etc. — into black, grays and white in order to render a believable drawing in pencil or charcoal. When you look in the distance, you can see that mountains, trees, houses, and other objects are much lighter than are objects in the foreground. What causes this phenomenon is dust particles in the air dif-

fusing the colors of sunlight, giving a lighter blue-grayish look to objects in the distance.

To the right is a value scale showing four shades of gray plus black and white, which should be enough values for you to start with. There is no rule on the proper number of values to compose a picture, but I suggest you start with no more than this amount to keep things simple. If, as you progress, you find that you would like to work with more values, do so.

Below, you see a photograph of a typical landscape with boxes of gray values plus black and white. These indicate how you might convert the greens, browns and blues of nature into grays, black and white. If you look closely at the photo, you'll see that I could have added more grays to encom-

pass more of the values that are visible in the picture. But the object is to simplify, to say more with less. Remember that you are creating a drawing, not duplicating what a camera can do.

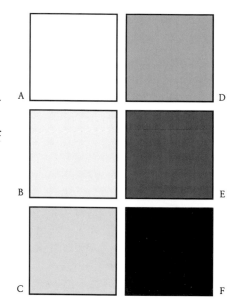

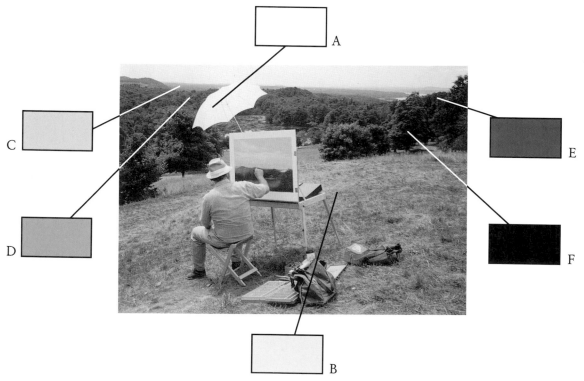

Seeing Values
Compare the value boxes in this photo with the value scale (above right); you will see that the values are the same. Once you develop a value scale, try to stay within those values. It will make drawing outdoors a lot easier.

DRAWING NATURE

TRANSLATING VALUE SKETCHES

If you squint your eyes or use amber-colored sunglasses, you can break down the landscape to about three values—a light, a mid-tone and a dark. Most people, in the beginning, tend to overestimate the number of values they see in the landscape. Naturally, there are more than just three values, but the simpler you indicate your sketch, the easier it will be to translate your value sketch into a drawing when you get back to your studio.

Using the value scale on the previous page, make a simplified line drawing of the scene before you (as shown in sketch *A*). Then indicate the values using a numeral or a letter to key one to the other. The basic rule is to simplify.

Sketch *B* shows how your value diagram translates into a value sketch, using just the limited six-value scale. Compare this to the finished drawing at bottom.

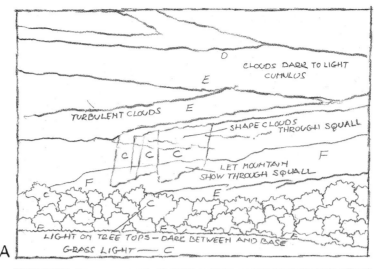

A

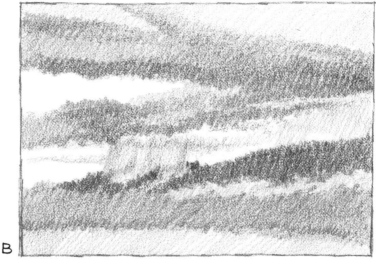

B

Mountain Squall
4½" × 6½"
Graphite on 2-ply Strathmore bristol.

The finished drawing shows the values and details that were added with the help of my two sketches and memory.

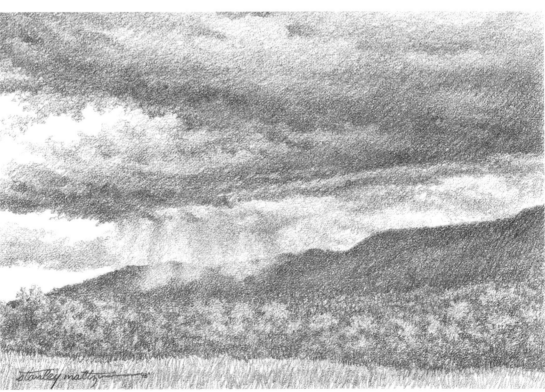

FOREGROUND, MIDDLE GROUND, BACKGROUND

In the previous pages, we have discussed seeing values and translating values from nature to your drawing. Now I would like to introduce you to the three "Gs"—foreground, middle ground and background. Most landscapes have all of these in their composition, and they may vary in any imaginable combination.

In the examples below, the hay bales and grass are the foreground, the trees and mountain are the middle ground, and the sky is the background. Look them over and see if you can pick out the three major values—dark, midtone and light—in the foreground, middle ground and background. The scene is the same in each example, but as you can see, you can create various moods,

weather conditions or times of day just by changing values from light to dark.

Now is the time to make thumbnails to help you decide the placement of values in your foreground, middle ground and background; what will dominate your drawing; and what combination of values will tell your story.

In the drawing at right, titled *Round Bales*, I have conveyed—

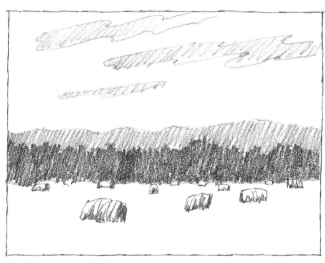

A

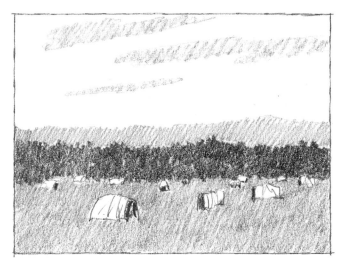

B

In sketch *A*, there is a predominance of light values in both foreground and background, creating what could easily be a bright, summer day.

Sketch *B* tells you that it is still a bright day, but more toward late afternoon. Notice that the lighter-value bales of hay have become more prominent.

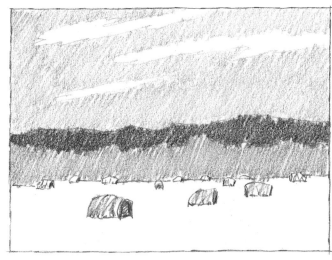

C

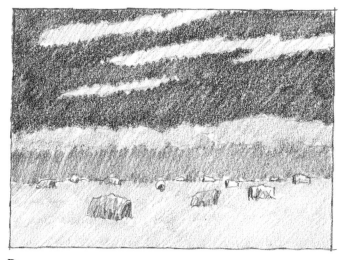

D

A value placed in the sky changes the placid summer day of sketches *A* and *B* to a possible storm approaching, or to late afternoon.

Dusk is upon us. In all four sketches, my three "grounds" remained the same. Only my values changed to create various times of day and different atmospheric conditions.

DRAWING NATURE

through the proper use of values
and placement of foreground, mid-
dle ground and background—a
sense of a hot summer day, which
is usually found around haying
time. Thus my picture has a truth
about it and is believable.

Round Bales, 5½″ × 7″, graphite pencil on Strathmore 2-ply bristol.

My finished drawing is a synthesis of the foreground and middle ground of sketch
B with the background (sky) of sketch C, which I felt would better create the
mood of the day.

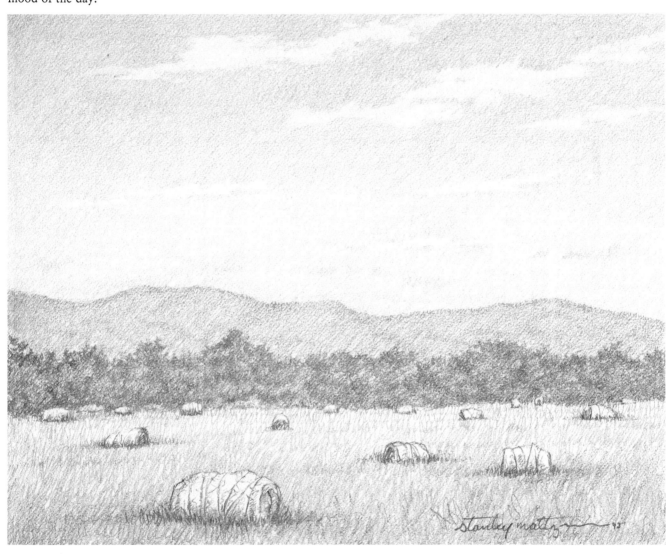

SIMPLE PERSPECTIVE

Using perspective in landscape drawing can be perplexing and challenging, but perspective is one of those important elements of picture-making that makes your picture believable. Here, we will talk about simple one- and two-point perspective.

Where your eye meets the horizon is called the *eye level* or *horizon line*. That imaginary line is a straight, horizontal line. The horizon line will naturally change as you lower or elevate your viewpoint. If you elevate your view-point, you will be looking down at the horizon line. This is called *above eye level* or *bird's-eye view*. If you are below the horizon line, it's called *below eye level*, or *worm's-eye view*. The horizon line or eye level, once established, does not change. There can be only one horizon line in any one picture.

Somewhere along that horizon line is the *vanishing point*, an imaginary point where parallel lines eventually meet. When you look at railroad tracks, you notice that in the distance the tracks seem to converge at one point. That is the vanishing point. Sketches *A*, *B* and *C* illustrate this simple one-point perspective.

In two-point perspective, two sets of parallel lines go to two vanishing points (see the diagram on the next page). This is important to remember when you are including houses and barns in your landscape, because not every barn or house will be situated with its front plane parallel to your view or picture plane, as in one-point perspective.

One-Point Perspective

In the diagram at right, all parallel lines at an angle to the frontal plane converge to one point—*VP*—the vanishing point. The bench and open box are below eye level, so you see inside the box and the top of the bench. If they were moved closer to the VP, you would see less of the inside of the box and less of the bench seat.

Drawing *B* shows a plowed field. Like railroad tracks, the furrows recede to one point along the horizon line, which is the vanishing point.

In drawing *C*, a meandering stream diminishes in width as it reaches the horizon line, and disappears into a field or valley beyond. That point on the horizon line is the VP.

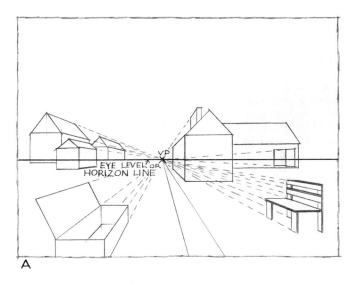

A

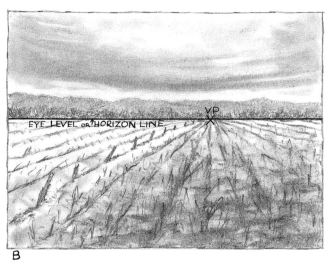

B

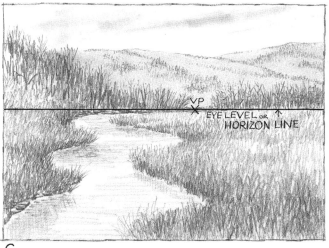

C

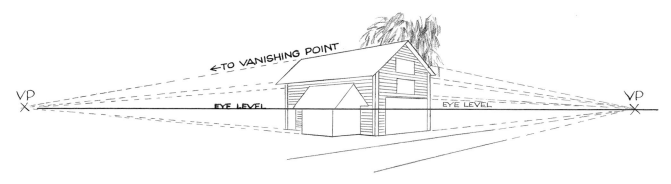

Two-Point Perspective

Because the old barn and shed are situated at an angle to the artist's viewpoint, the front and side of each building have their own vanishing points. That means all parallel lines on each plane converge to their own vanishing point, one to the right, and one to the left, as shown in the diagram above.

Once you decide on your horizon line or eye level and your vanishing points, the remainder, like roof angles, clapboard, windows and doors, will all fall into their rightful place. For a better understanding, lay a piece of tracing paper over the finished drawing below and trace the lines to their respective vanishing points.

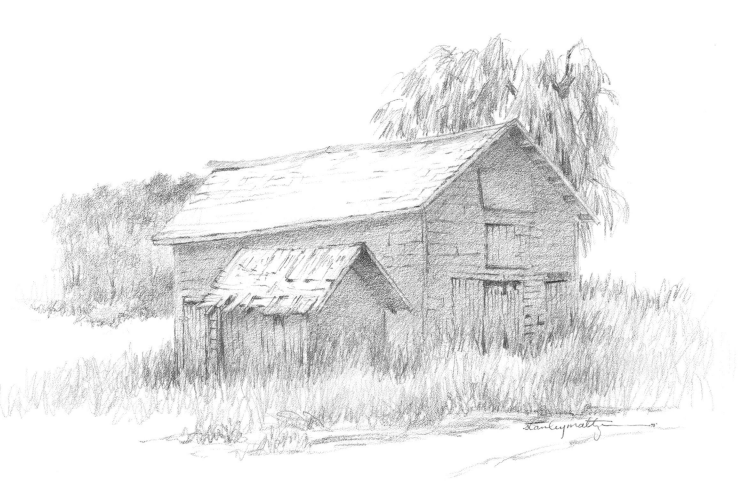

Road Side, 11″ × 14″, graphite pencil on 2-ply Strathmore bristol.

LIGHT

By suggesting the effects of light and shade, the artist can create three-dimensional form on a two-dimensional flat surface. Light defines and can suggest depth, weight, softness and space. Darks tone down as well as express form, texture and strength. Imagine trees without shadows, or a barn without texture, or a forest of trees without the flickering lights of the sun filtering through the leaves. As important as light is, just as important are the shadows, because the shadows explain whether objects are flat or round, whether it is a bright or a cloudy day. They create a mood and they help tell your story.

When you start your drawing, the sun (the primary light source) will be in a certain position. As you work, the sun will move across the sky, creating new shadows, which can change the feeling that inspired you to select this particular area for a picture. There are several remedies for this situation. One is to work the same time every day, or from one particular hour to the next. Another is to make as many line-and-value sketches as you need to help you recapture the scene when you get back to your studio. Last, if you do not intend to return to a particular spot, use your camera. Sketches, notes and photos should give you enough material to capture that light you wanted to preserve in your drawing.

In the vignette below, you see the open doorway of a barn. The front of the doorway receives the primary source of light; therefore, all objects facing that light will be the brightest in value. As the light recedes into the interior, the values will darken and become almost black. In spite of the dark interior, your eye can pick out a few details. Included are just enough details to let you know that something is there, which is more interesting than just a dark shape.

There's also a secondary light source—the window, which, being on the shady side of the barn, does not allow light as bright as the primary source inside. The papers on the top of the pile receive most of the secondary light, which is a little darker in value than the primary light, which shines on the bottom part of the trash can.

Barn Interior, 14″ × 17″, graphite pencil on Somerset paper.

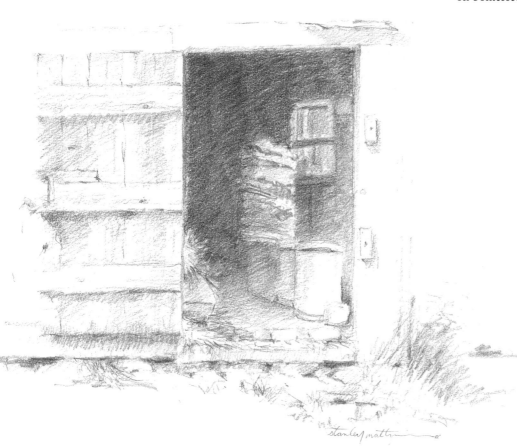

D R A W I N G N A T U R E

REFLECTED LIGHT

Reflected light is the light that bounces back from the surface an object is resting on, or from surrounding objects. Reflected light will appear on the shadow side of the subject or in other areas of shadow; it should never be brighter than the surface receiving light from the primary light source.

In these rounded river rocks, the subtle rim of light on the shadowed side is reflected light, which helps define the rounded form of the rocks.

Reflected Light

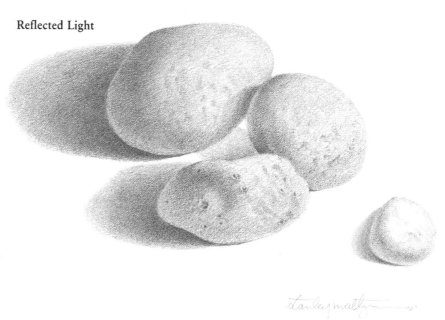

SHADE AND SHADOW

In sunlight, all form becomes clear and sharp except for objects receding in the background or distance. Shadows are distinct and reveal to the viewer whether the terrain is flat or hilly. Grass in shadow is an excellent example of this, as it conforms to the contour of the land. In the sketch at right, you will notice a boulder in the path of the tree shadow. Shadows do not go around objects; rather, they follow the contour or shape of the object, in this case a boulder. The shadow goes over the boulder and resumes the shape of the tree as it continues up the grassy slope.

On a cloudy or foggy day, strong light is not present. Shadows and objects are diffused. This loss of light causes little contrast, which keeps subject matter in low key and weak in definition. Colors lose their intensity, and everything is darker in value.

Shade and Shadow

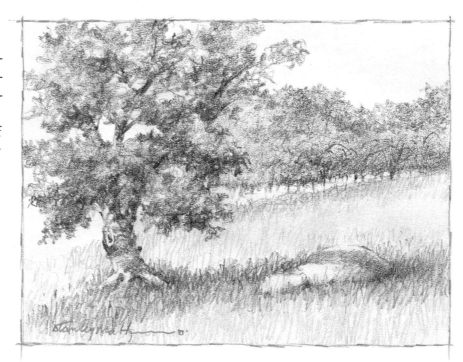

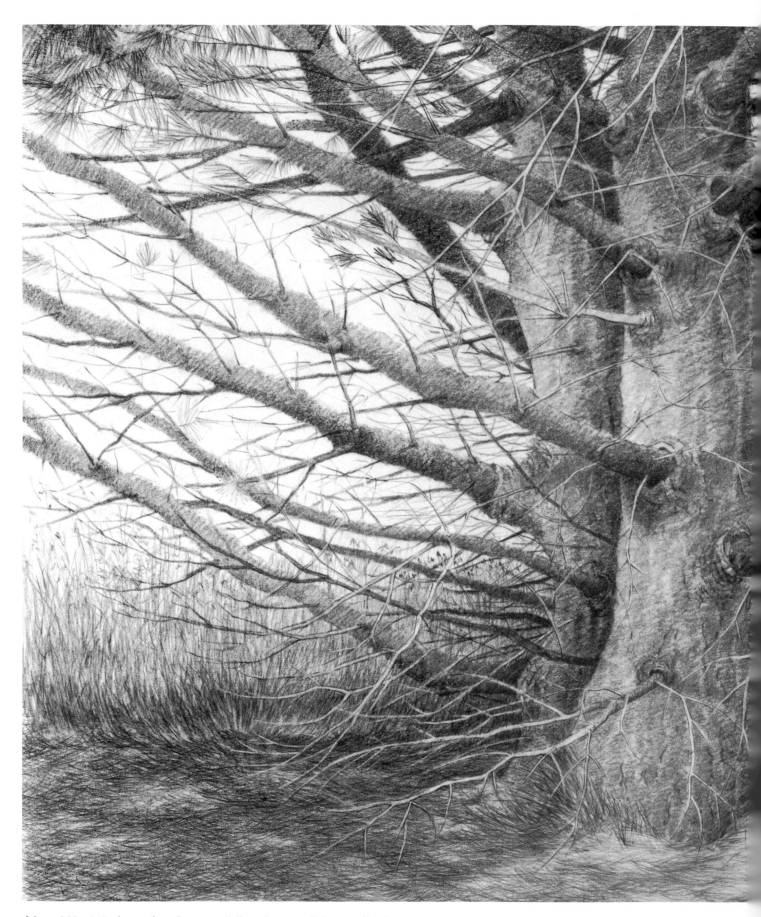

Maze, 22″ × 31″, charcoal on Japanese (Misumi) paper. Private collection.

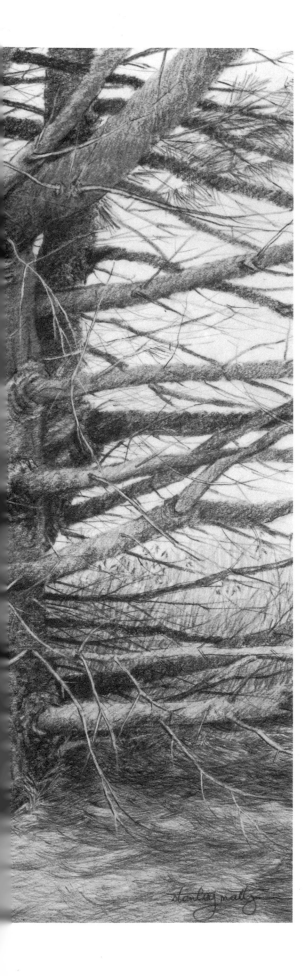

Trees

I have always been a student and an admirer of trees. Trees are tall or short, wide or thin, strong or weak. They are beautiful and haunting. Masculine and feminine. But the wonderful thing about trees is that they are what you see and make of them. You as an artist should study and sketch trees during all seasons.

Trees have an identifiable pattern to their foliage and a character of their own. Their trunks and branches grow in a distinctive pattern. Have you ever noticed how much color there is in a winter forest, or how a tree will lean away from its neighbor as it reaches for light and growing room? While you are outdoors drawing, study the trees in your vicinity so that in time you will be able to make a maple or an oak recognizable in your pictures without showing every leaf. Shapes will tell the story.

CAPTURE THE CHARACTER OF A TREE

To present trees in your drawings that have a reasonable resemblance to the type of trees you wish to portray, you must study the characteristics of the various trees you come into contact with.

If you squint your eyes while looking at a tree, you will see a pattern of darks and lights, as illustrated in Sketch *A*. All trees have a pattern to their foliage; it's different for each tree, but it's a definite pattern.

Drawing *B* illustrates an oak tree in which the main trunk usually grows straight and supports many heavy branches coming from the sides. Another outstanding characteristic of oaks is the way the lower branches distinctly face downward.

Drawing *C* shows a young cottonwood tree, definitely not a heavyweight like our oak friend. This type of tree has one main shoot with thin branches growing out from the sides.

Drawing *D* has an ash silhouetted against some pines. This is a good way to make a light tree come forward and to give your drawing depth.

Drawing *E* shows a locust tree, one of the family of trees that has a main trunk that splits into several large branches. This is only a partial drawing of the locust. I created the gray tone using a stomp, then I came back with a charcoal pencil for a different effect.

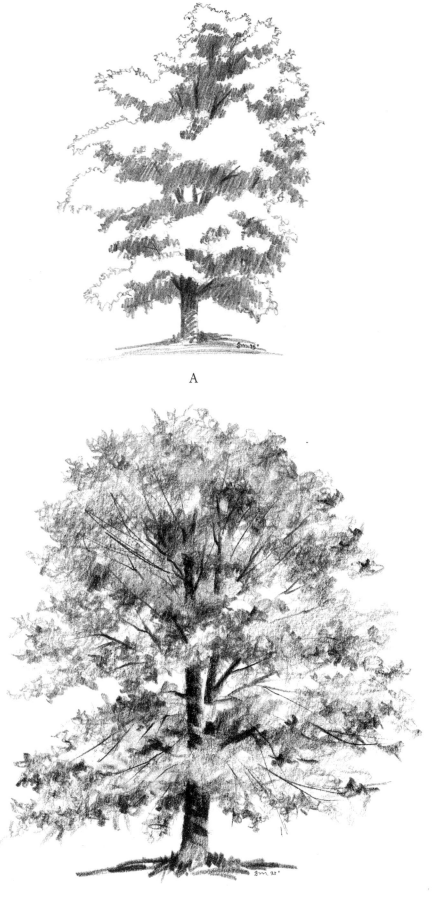

A

B

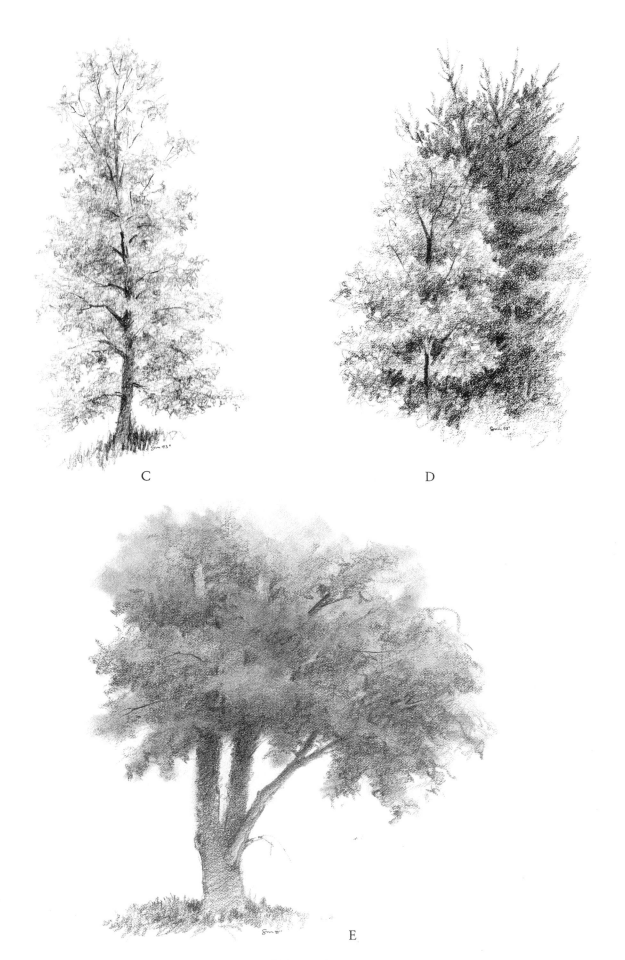

C

D

E

TREES

PINES

Pines can add a feeling of tranquillity to a landscape, and pines without needles can express great drama. Pines can also add a sense of beauty and interest to your work by the way you express the various shapes—tall, short, full, sparse—and the beautiful patina and irregular designs of the branches and trunks without needles. Pines will grow close to one another, interweaving their limbs and branches, whereas other trees will bend away from anything growing close.

The drawing (right) shows a fir. Firs grow wider and fuller and into a conical shape, making them very attractive around Christmas. Remember to strive for a sense of reality. Be aware of the shapes. They do not have to be botanically accurate but should be artistically pleasing. Later on, if you desire, you can increase your knowledge and make trees as botanically accurate as you wish.

The drawing (below right) depicts a group of spruce; in the background is a forest of pines. On the left, I let light appear through the branches, which gives the appearance of a sparse forest. On the right, I filled in the trees with tone, not letting the light in, to create a denser-looking woods.

The large drawing (opposite page) is a white pine, a very graceful tree often found by itself in the fields and meadows. I used HB, 2B and 6B charcoal pencils on Fabriano Ingres paper.

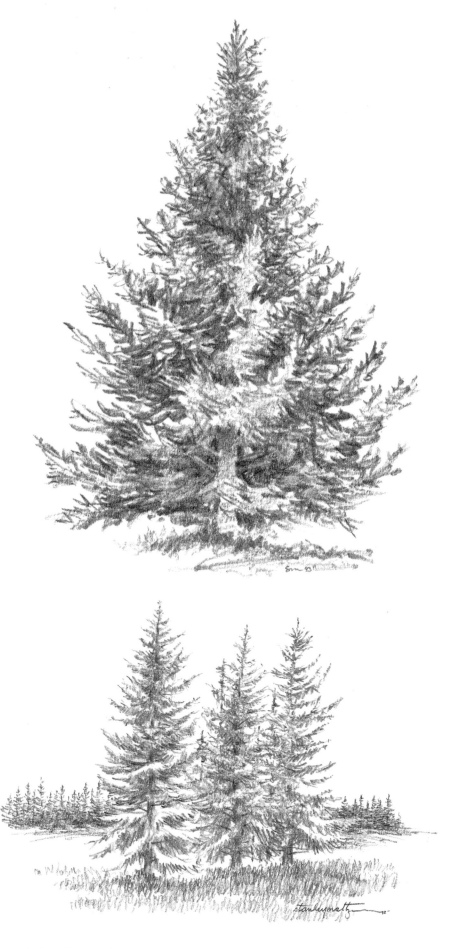

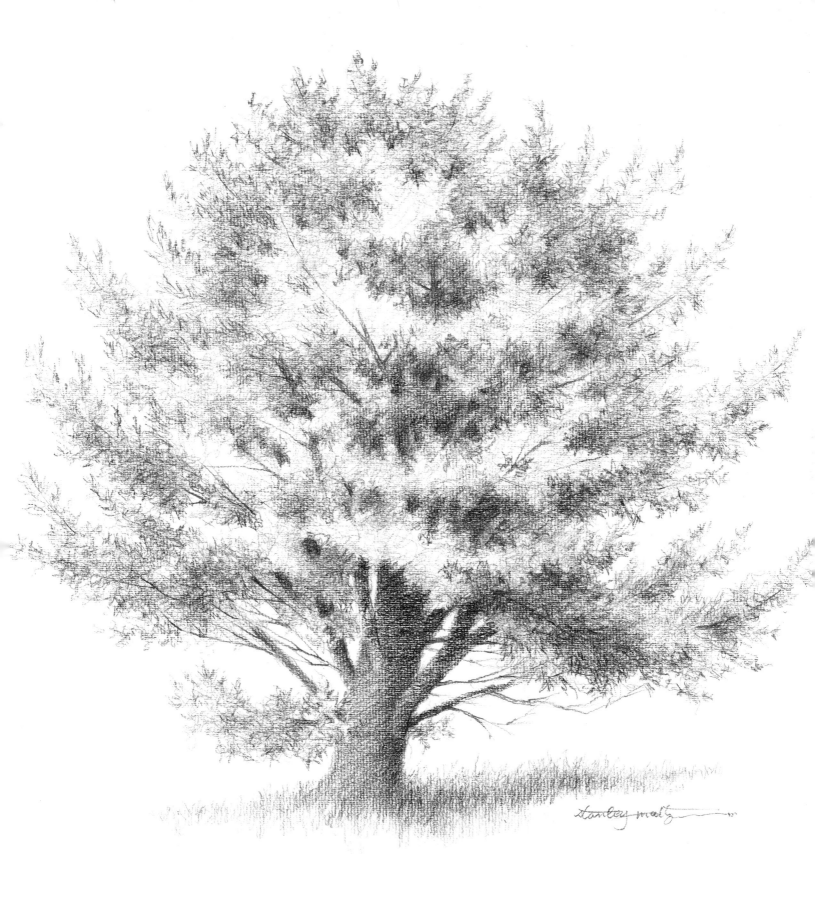

TREES

MAPLES

Maples are some of the most admired and beautifully shaped trees. They are usually symmetrical, and the tops are rounded more often than not. They are abundant in foliage with a definite pattern. The graphite-pencil drawing (lower right) shows a mature tree with its symmetrical shape. In the fall, the maples usually put on a color demonstration (reds and yellows) that artists are forever seeking to capture. In the winter forest, one can always pick out the red maple by its twigs, which have a red cast to them.

Another characteristic is the way the tree grows. It has close branches that grow fairly straight up from the main trunk, and then has many limbs and twigs shooting from the sides, as illustrated in the drawing (lower left).

The large drawing on the opposite page shows a close-up of a group of maples sketched in charcoal on Strathmore bristol. In aging maples, the trunk and limbs offer unlimited design opportunities to incorporate great character into your drawings.

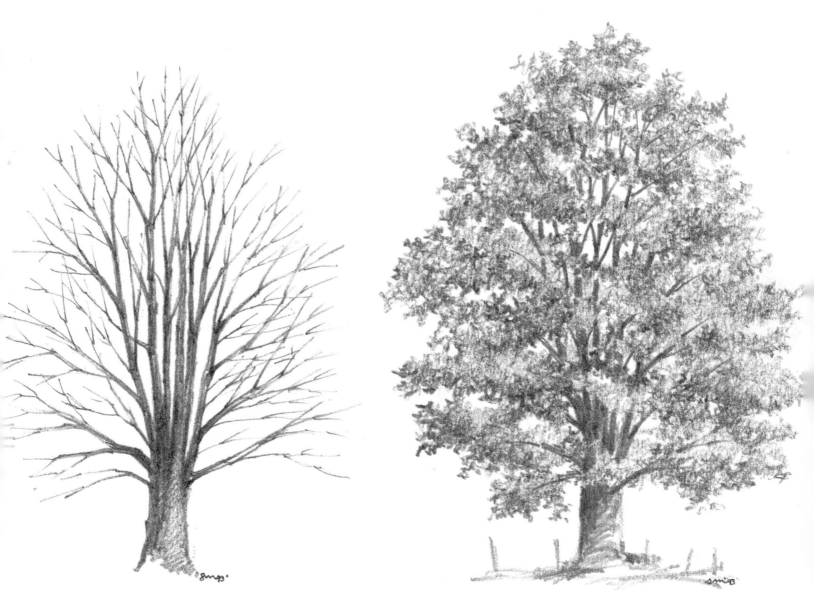

DRAWING NATURE

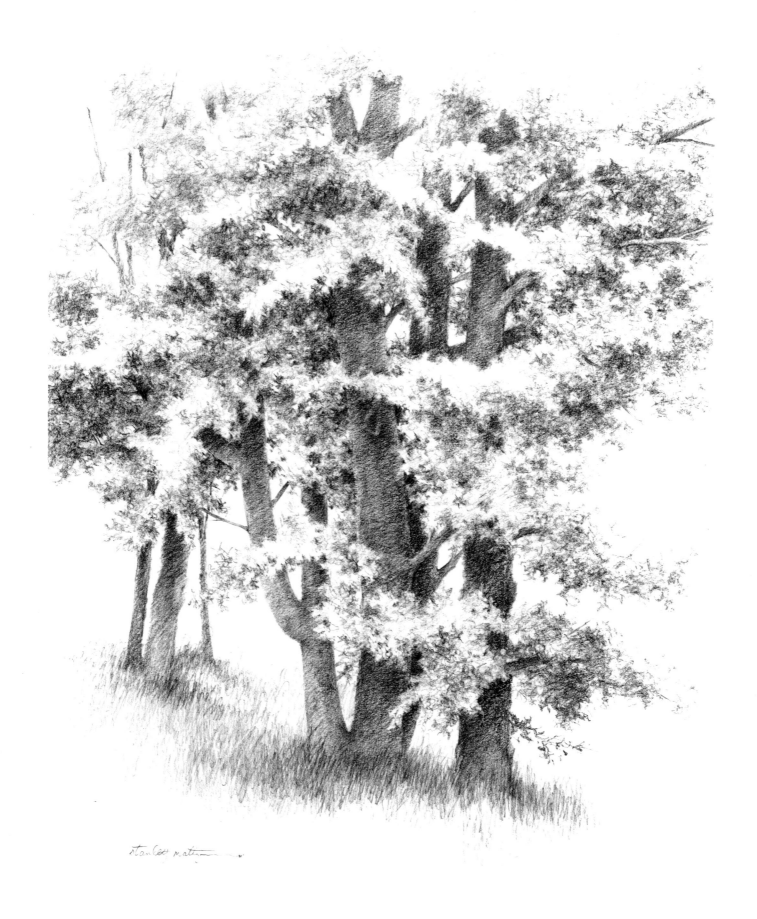

TREES

OAKS

Some of the most distinctive characteristics of oak trees are the heavy boughs with twisted, angular branches. These boughs and branches can easily be seen because oak trees have many more sky holes than most trees. Another outstanding feature is the downward thrust of the lower branches, as shown in the graphite-pencil drawing at right. The foliage is often heavily branched, and in the fall, it puts out a beautiful scarlet and red-orange leaf. Whereas most trees drop their leaves in the fall, oaks maintain their leaves throughout most of the winter, adding more color to the wondrous winter woods.

The drawing below was executed with charcoal and water on 2-ply Strathmore bristol board. Start with a 2B charcoal pencil and just indicate the foliage. Then take a bristle brush dipped in water, wipe a little off on a rag, and go over the drawing, pushing the charcoal around like paint. When this dries thoroughly, take a 4B charcoal pencil and add the wood to the tree and some darks in the foliage. Then go over the drawing once more with your wet brush. As you can see, the results are interesting. The tree has a nice texture. Try some oaks using various papers.

The large drawing on the opposite page is a charcoal-pencil drawing of a red oak executed on Strathmore bristol board. Notice the abundance of sky holes.

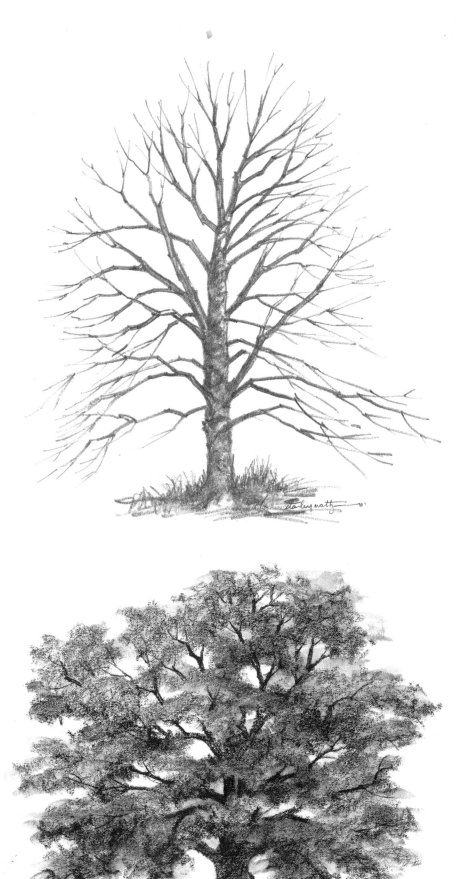

DRAWING NATURE

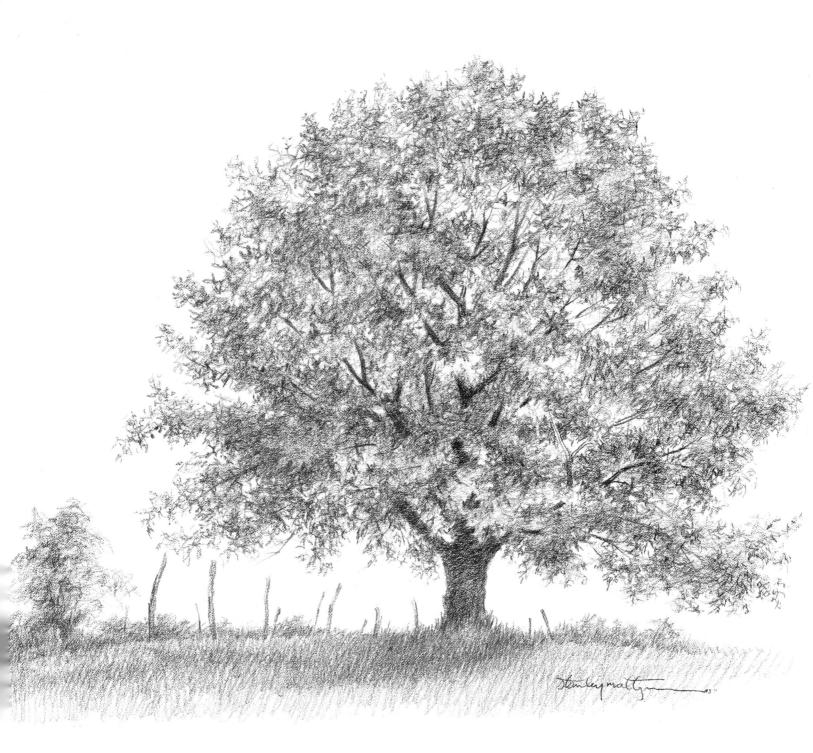

BIRCHES

Birches, to me, have always seemed to be the elegant ladies of the forest. When depicting birch trees, keep that in mind and use a light hand, especially with silver or paper birch trees. The paper birch, sometimes called the *canoe birch*, grows much heavier than the silver birch and always seems to be shedding its bark. The bark is very durable: You might find a birch with the insides completely rotted out and the bark in perfect shape. Another feature that appeals to artists is the black spots, which are very apparent on the light-toned bark. These spots indicate where a branch was. Keep these spots simple, and don't place them all over the tree.

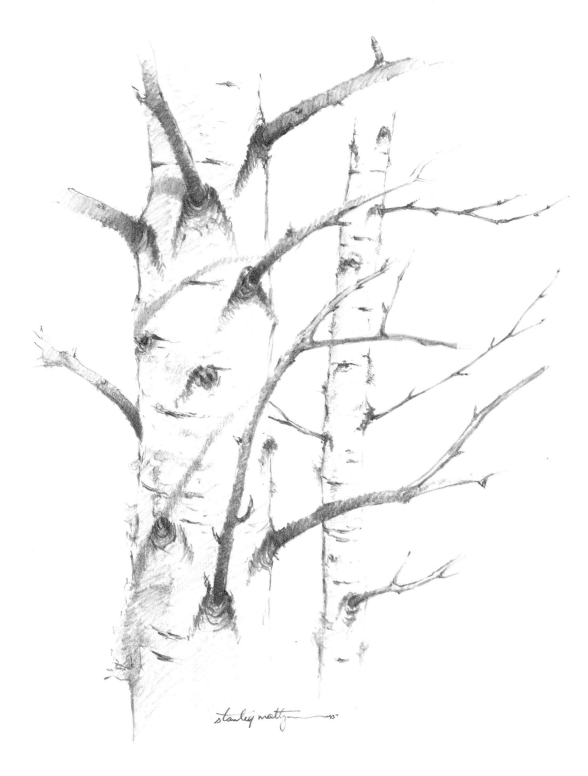

DRAWING NATURE

Think design and leave some out. Plan your drawing so that your birches are placed against a heavily wooded or dark area. The light against dark will display them to their best advantage.

The sketch at left, done in graphite pencil, shows the characteristic branch pattern and the spots where branches were.

The *Grand Old Birch* (below) was drawn with 2B and 4B graphite pencils on Strathmore bristol. This particular tree is one of the few remaining birch trees planted by Frederick Church. Even though it was large and old, I kept a light touch with a minimum of darks for balance and design, which enabled me to portray its dignity and strength.

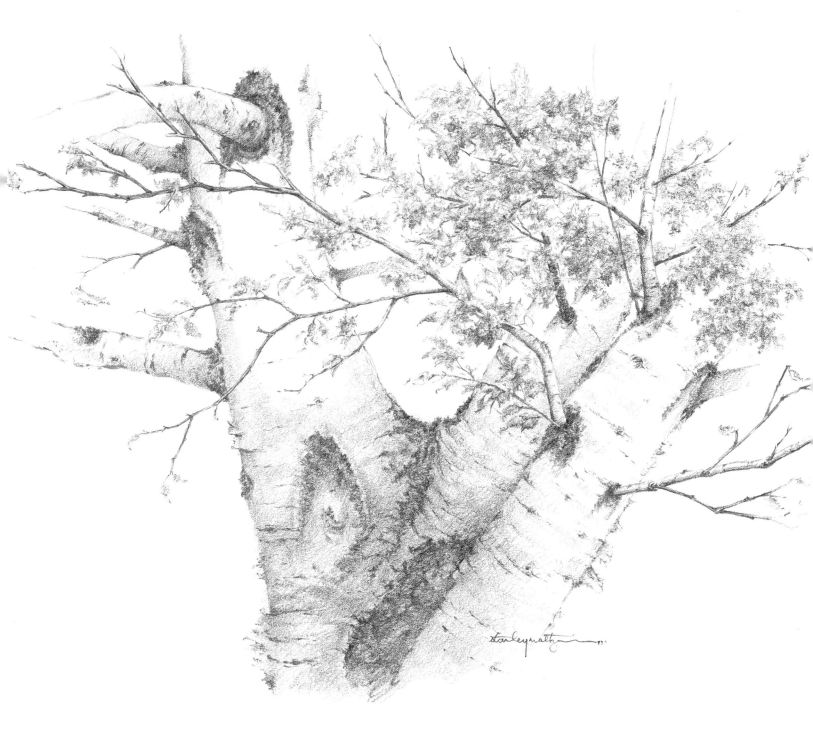

APPLE

Apple trees are fabulous characters to draw. They have something to offer the artist at any time of year. In spring, it is blossoms; in summer, foliage; in fall, fruit; and in winter, the wonderful bare trunks and limbs offer their intricate designs.

Winter Orchard (below) was worked from inside my old Scout 4 × 4. I had driven by this orchard so many times that the picture I wanted to create was well worked out in my mind. The various odd shapes always appealed to me —

they remind me of soldiers on a parade ground all lined up for inspection. I used a ¼-inch charcoal stick on a piece of handmade Japanese paper. The charcoal was shaped like a chisel: I used the broad side for shading and the opposite side for as fine a line as I might need.

The landscape *Cherry Ridge Farm* (right) was drawn in the Catskill Mountains; it is a good example of working darks against light and lights against dark. I used 2B and 4B charcoal pencils on 2-ply Strathmore bristol.

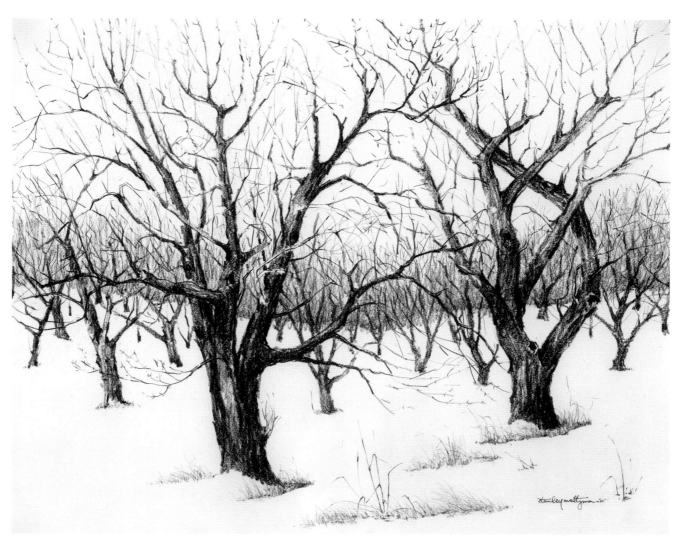

Winter Orchard, 20″ × 30″, charcoal on Japanese paper. Collection of Len and Claribel Gardner.

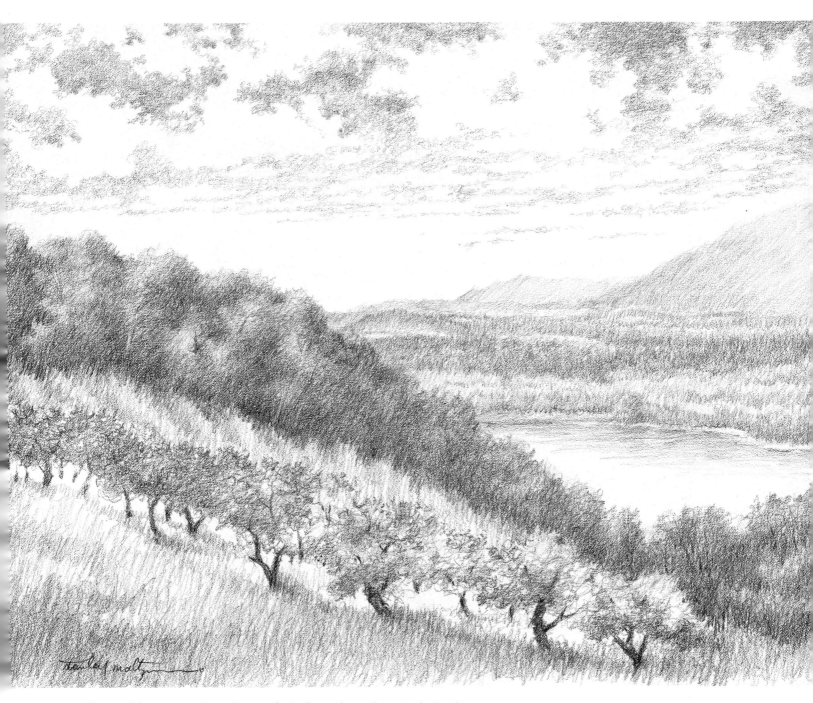

Cherry Ridge Farm, 11″ × 14″, 2B and 4B charcoal pencils on 2-ply Strathmore bristol.

DRAWING A TREE
WITH FOLIAGE

Before you begin to draw a tree with foliage, ask yourself some questions. Are you drawing the character of the tree? Is the tree representative of a specific species? Is it to be included in a landscape you are composing?

When you start to sketch your tree, sketch lightly and let it grow from there. Give the foliage a shape that's not too symmetrical but that shows some individuality. Notice here that the trunk is not exactly straight or centered. This was balanced by adding a heavy limb on the left side. Give the foliage a pattern of lights and darks, and suggest some limbs and branches protruding from the foliage. Where you left some sky windows, show some more wood. As a final touch, you can add some trees in the background, making your tree a part of the overall landscape. This tree was drawn with 4B charcoal on Strathmore bristol.

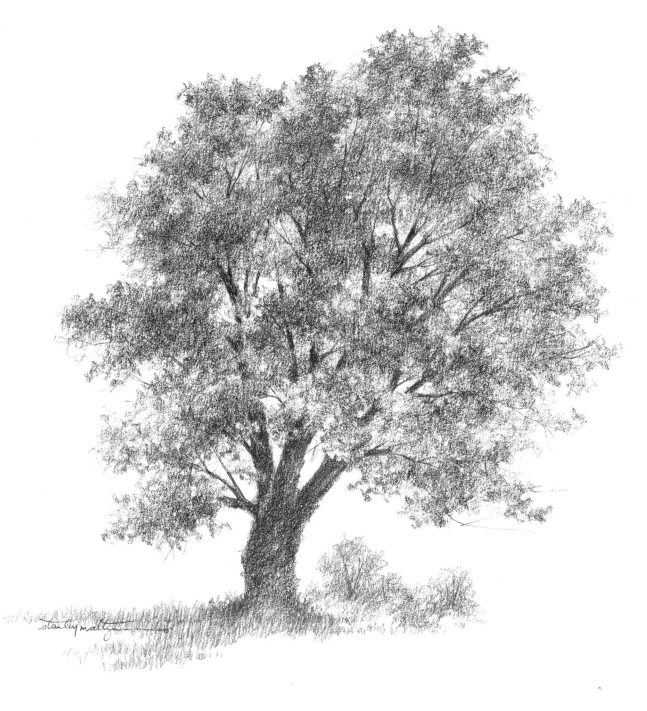

DRAWING NATURE

DRAWING A TREE WITHOUT FOLIAGE

Walking in a woods or forest during late fall and winter is a treat because it allows you to study the trees without their foliage. It is like being in a life drawing class—all these wonderful shapes just waiting for your sketchbook. Start by noticing the overall shape, both up close and from a distance. Notice how branches grow from the trunk and how they taper and get thinner toward the ends. Each new growth is in unison unless it has been disturbed by any number of elements. Each tree is a piece of sculpture. Sketch as many as you can, for when you learn to draw the anatomy of a tree, the foliage will fall into place.

The sketch below, *Woodland Ballerina* (charcoal on Japanese paper), earned its title because the top of the tree looked like a ballerina dancing with her hands over her head. It had great design and character. Odd shapes like this make drawing outdoors most enjoyable.

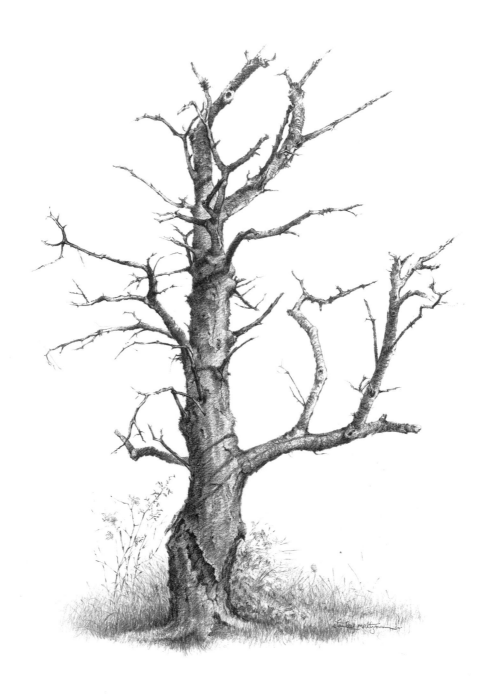

MASS OF TREES WITH FOLIAGE

Drawing trees in a mass, simulating a forest, is not as difficult as it sounds. Out of this mass you create a design, a pattern of lights and darks. Look for the shapes of the various trees silhouetted against one another. Be liberal about the sketch—what you want to capture is a reasonable facsimile, not an exact copy.

This sketch shows you, in three easy stages from top to bottom, how to create masses of foliage. Start by sketching the outlines of the trees. Be aware of repetition:

Vary the heights, make some wide, some thin, and so on. Of course, you will have many shapes that are similar, but indentations and the various darks will give them their individual characteristics. Do not be concerned with extra lines; they will get covered as you proceed.

Notice the two shaded areas in the outline sketch. I call them *eye markers*. They give your eye a spot to return to instead of drifting around looking for something familiar in that busy landscape.

With the outline finished, take

a B graphite pencil and lay in a middle value over the complete sketch. You can also begin some shading to contain your various shapes. Keep this light so that if you desire, you can change some shapes by lifting out tone with your kneaded eraser.

To finish your drawing, with 2B and 4B graphite pencils, start giving the shapes more definition: Add darker accents and include some tree trunks or tree shapes, as shown in the bottom third of this sketch. You now have a forest of trees!

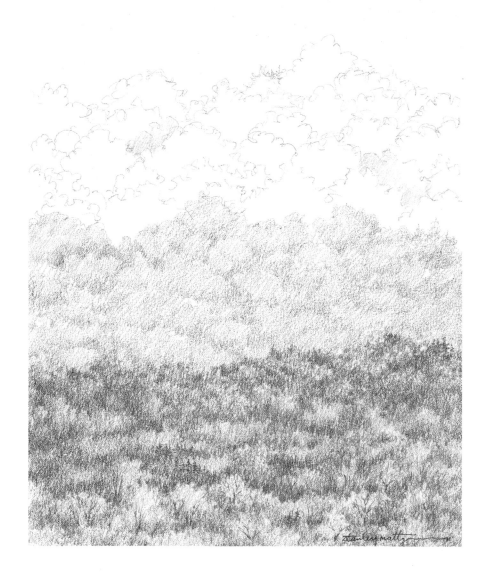

DRAWING NATURE

MASS OF TREES WITHOUT FOLIAGE

When you look at a forest, you see big and small trees, wide and thin trees. There are also numerous pine trees and trees that do not shed all their leaves. This means the forest is denser in some areas and thinner in others, providing an environment of various shapes to include in your drawing. A forest without foliage seems to be dozing, but it is very much alive and full of happenings.

Start your drawing as indicated by the sketch at the top. This is your guide, your thinking. You do not have to adhere to this sketch—you can change, move, eliminate if you feel it will im- prove your picture. In other words, be flexible.

Then, as shown in the middle third of the sketch, draw the dense part of the forest. Vary your darks and lights to give the appearance of heavy and light areas of woods. Be aware of the tops of the trees, which receive the most light and have the finer branches. Do not create hard edges. Keep them soft by gently pressing on the tops of the trees with your kneaded eraser to lift off some of the graphite.

Along the bottom, carry some of the strokes downward past the mass of tone to give the appear- ance of many trees and of greater depth.

Finally, as shown in the bottom third, add the remainder of your forest without foliage. Place some trees a little farther forward, away from the background mass, to give the impression of depth. Even though the trees are loosely rendered, there is a suggestion of maples, oaks and birches. The thin, white lines for the birches were created by impressing strokes with a stylus (metal in- scriber). When you run the lead pencil over that particular area, the pencil will skip over the inden- tation you made, leaving white pa- per. The sweeping strokes in the foreground were made with a wide carpenter's pencil.

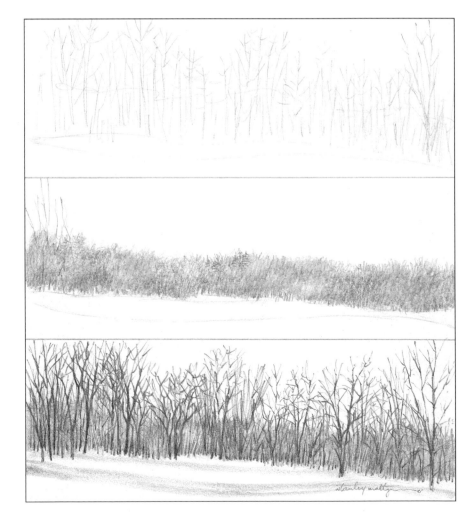

CREATING PERSPECTIVE WITH TREES

It is important to convey a feeling of depth, rather than a flat plane, in your landscape drawing. One way to achieve this feeling is by using trees to create perspective and excitement.

The small drawing of the wooded area, at top, portrays this feeling of depth. By varying the thickness of the trees and gradually adding heavier and darker trees as you move forward out of the woods, you create an atmosphere, which is further enhanced by adding the two larger trees in the immediate foreground.

Another means of creating perspective with trees is illustrated with the tree-lined road at right. Notice that the trees get smaller as they recede, and both the tops and the trunks are angled to the horizon line, which gives nice, simple, one-point perspective.

PERSPECTIVE ON A GRAND SCALE

Placing large, detailed tree shapes in front and gradually diminishing the sizes and the detail of the trees as they recede will give you the feeling of deep space. The tree-covered mountain range also creates perspective, but notice that even along the ridges, tree shapes are still apparent. By spotting some small trees around, we add to the appearance of vastness and depth. Be careful, though, not to get carried away indicating small trees. Detail is lost as trees recede.

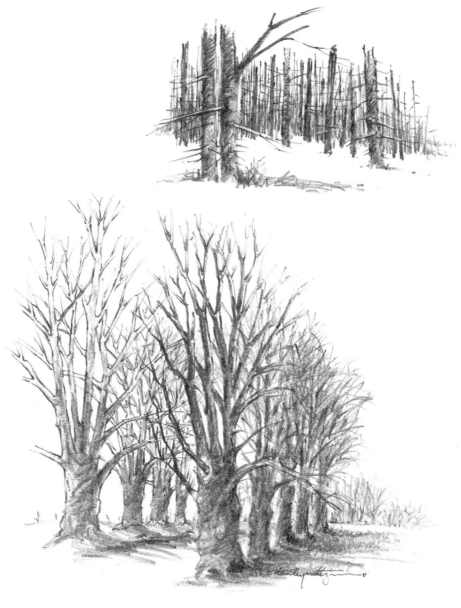

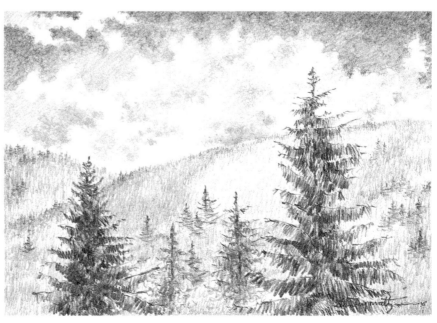

DRAWING NATURE

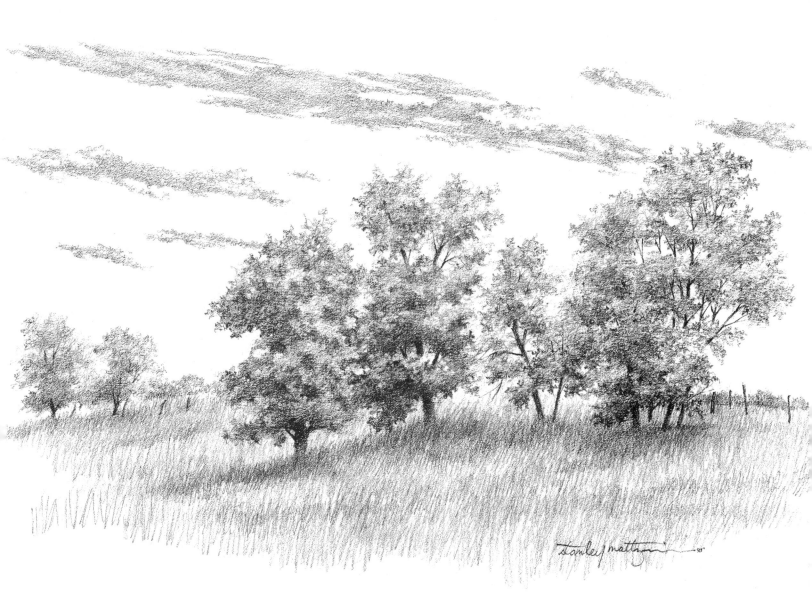

The landscape drawing above, called *Friends*, is a good example of how the use of perspective with trees helps to create the center of interest in a composition. The positioning of the trees moves your eye to the center of interest, which is the foremost tree in the group. The taller tree on the right and the next smaller trees help form a line leading to the left. The stronger shadows in the grass do the same. Your eye travels down to the foremost tree. It may jump to the two smaller trees on the left for a minute, but it comes right back to that first tree. This drawing was done with graphite pencil on 2-ply Strathmore bristol.

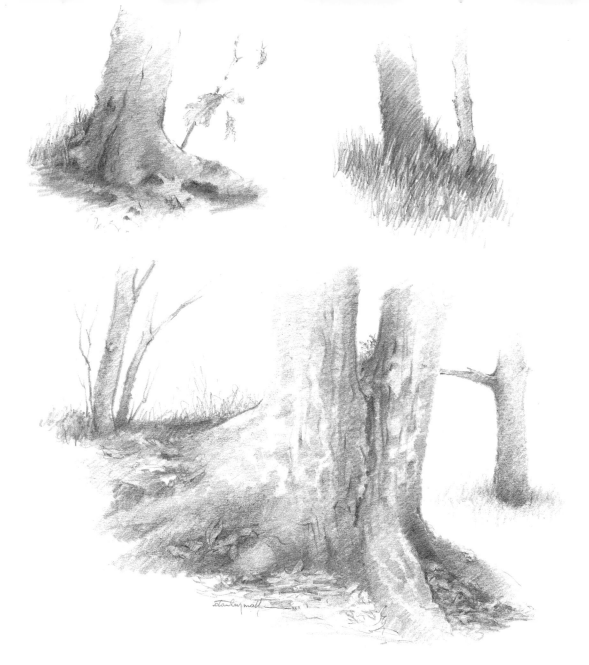

ANCHORING TREE TRUNKS TO THE GROUND

Trees do not sit on top of the ground. Instead, they extend upward from a vast root system beneath the surface. To convincingly draw tree trunks as if they are anchored and growing out of the ground, your main concerns should be the contour of your tree and the place where the tree is growing. Is it in a grassy field? Bare earthy ground, or forest floor? If your tree is growing in a grassy or weedy area, show some of the grass hiding part of the trunk or have a few blades of grass growing up in front of the trunk. As illustrated by the two small trees above, you can place light blades of grass against a dark tree trunk or vice versa.

Another way to show the tree in the ground is to continue the oval shape of the tree, but do not make it perfectly round. Leave a little irregularity, such as earth or small stones showing. It will look more natural.

Drawing the exposed roots of a tree can be very interesting because of their varied shapes. Look at the two large trunks with roots: Notice that some are short and enter the ground abruptly, and others seem to snake around before going into the earth. Also, see how debris like leaves and twigs get caught around the roots. Details like these help show where the tree is growing; they tell a story and create interest. Most of the leaves were made by removing tone with a kneaded eraser and then coming back in with the pencil to accent some of the shapes.

BOUGHS, LIMBS AND FORESHORTENING

As a tree grows, it sends out boughs, branches and smaller growth that diminish in width as they grow. Therefore, when you sketch a bough coming from a trunk, remember not to make it the same thickness as the trunk. The same principle applies to branches from boughs and to smaller growth, like twigs, from branches.

In the bottom drawing, you see a branch that appears to grow from the tree toward you. This is called *foreshortening*. You can create the illusion of foreshortening by making the branch larger as it comes toward you, and smaller at its place of origin. You can carry this illusion further by including more detail in the branch the closer it gets to the viewer's eye. Another way to give the appearance of foreshortening is by darkening the trunk behind the branch and lightening the branch coming toward you.

Often a growth from the tree will leave an indentation in the main trunk or grow a sort of collar around the circumference. Including this in your drawing gives the boughs and branches a look of being attached or belonging to the trunk. And be aware that when branches grow downward, they should be drawn lighter in value, since they get more light. When they grow upward, they should be darker in value. Drawing the upper sides of branches in lighter values and the lower sides in darker values gives the appearance of roundness and weight.

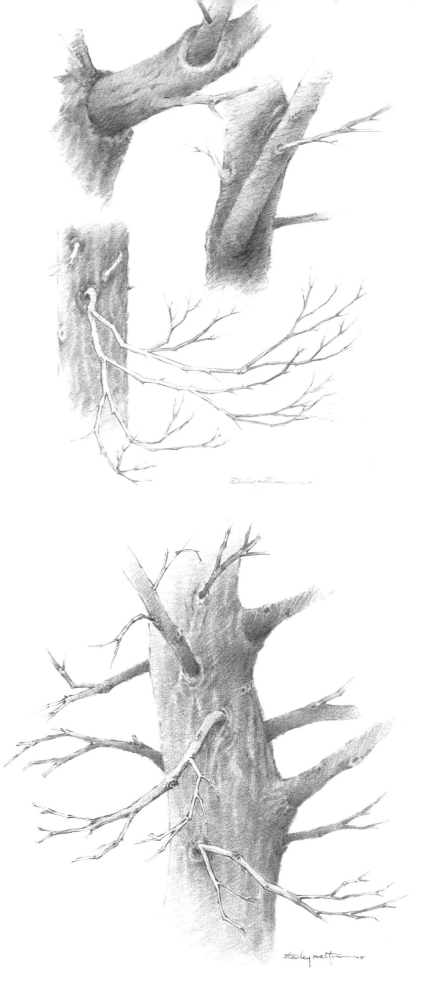

KNOTHOLES

Knotholes appear usually after a tree loses a bough or a limb. The tree grows a collar, which is its way of sealing and healing its wound. In most cases it works, and you can see these beautiful shapes, which always bulge outward. When the wound does not heal, rot and decay will develop, as illustrated in the large center sketch below. This also creates an interesting design for the artist. Look for a definite pattern taking place in the cavity. It is the way the grain of the tree flows: The soft wood decays first, leaving the hardwood. This erosion creates beautiful, intricate designs. Do you see the leaves growing on the side of the tree in the sketch in the center of the page? Those three leaves together indicate poison ivy. If you are going to work outdoors, become acquainted with the characteristic three leaves so that you can avoid them. And yes, poison ivy does climb.

In the three-step drawing opposite, I've shown you an easy way

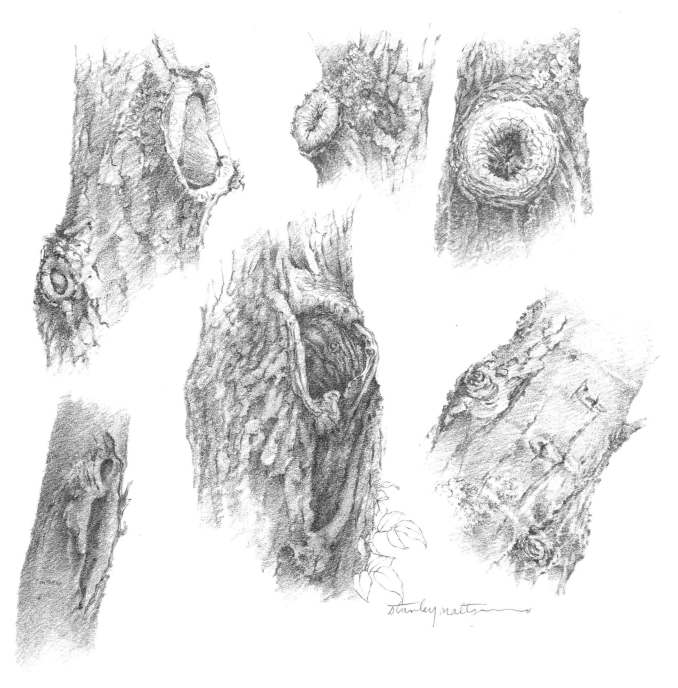

DRAWING NATURE

to create these knotholes. I began with a 2B charcoal pencil on a piece of 4-ply museum board. Without too much pressure on the pencil, I made a loose sketch without being too concerned with the accuracy of the bark. My main intention was to capture a fairly good resemblance of the knotholes and the flow of the bark around them. In the middle sketch, I used a piece of medium-vine charcoal and covered the whole drawing except for the knotholes. Then, with my stomp, I smoothed out the marks of the charcoal and softly hit the collar around the knots to remove some tone. In the final step, with the vine charcoal, I carefully empha-sized the bark around the knots and added some darks here and there. I picked out a few high-lights with my kneaded eraser, and satisfied with the results, I sprayed a couple of light coats of workable matte fixative. (Be sure to let each coat dry before apply-ing another coat.)

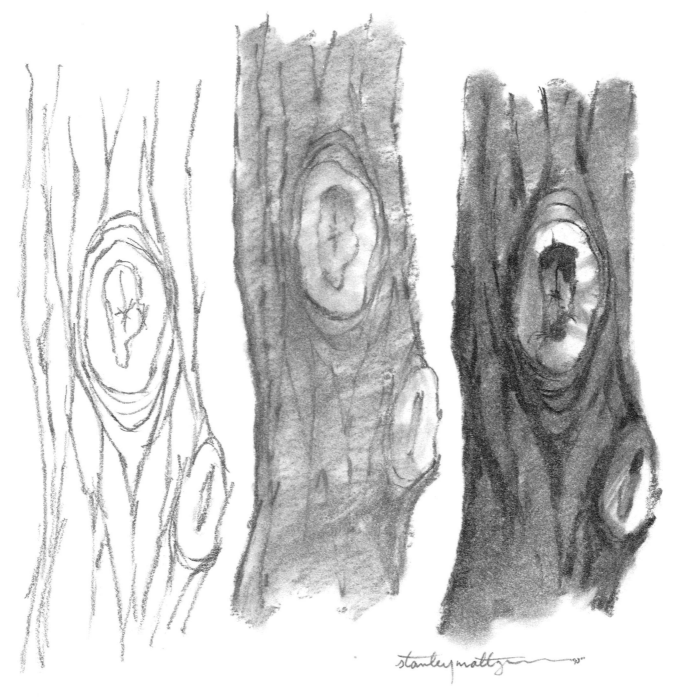

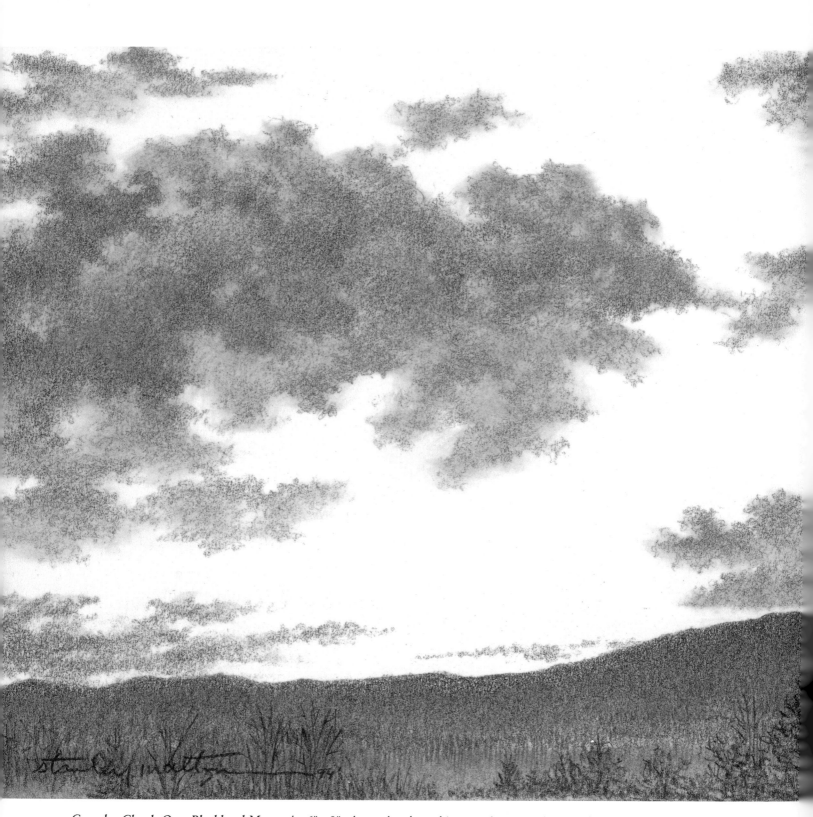

Cumulus Clouds Over Blackhead Mountain, 6″ × 9″, charcoal and graphite pencils on Strathmore Alexis paper.

Clouds

To the outdoor artist, the sky is of utmost importance. Changes in light and changes in cloud formations alter the appearance of the landscape below, which can inspire—and challenge—the artist. Cloud formations may vary from a cover of clouds occupying the entire sky, such as on a gray day, to clouds that seem to rush across the sky leaving beautiful shadows on a green mountainside. Another day, one might see giant cumulonimbus clouds building and growing in size, just waiting to pour down rain somewhere, while the sun's rays are peeking through in another area. Depending on the cloud formations and the particles of dust and moisture in the atmosphere, a sunrise can give everything an orange or pinkish hue. Many artists have tried to capture those wondrous colors provided by the greatest painter of all time—nature.

What all this calls to your attention is the importance of clouds. A poor sky can easily spoil a good landscape. In the following pages, I will introduce you to cloud formations that will add strength and beauty to your compositions.

KINDS OF CLOUDS

Clouds are developed in the atmosphere by the prevailing winds, moisture and dust particles. Familiar cloud names are *cirrus*, which are high flyers; *cumulus*, which are middle-level clouds; and *stratus*, which are the low clouds. Each one of these types has other members of the same family, such as *altocumulus* or *stratocumulus*. When you go outdoors, notice the cloud shapes overhead. You'll be surprised by the variety.

Cumulus

Cirrus

Altocumulus

Stratocumulus

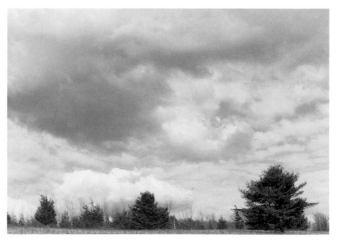
Cumulonimbus

CIRRUS

Cirrus clouds appear in many different forms, most memorably as wisps of drifting, delicate, feather-like plumes. These clouds are composed of ice crystals. The degree of density, color (whiteness) and delicacy in their appearance is guided by the amount of crystals present. Cirrus clouds are very apparent at sunrise and sunset, showing their reds and yellows before most clouds, and usually maintaining their colors after other clouds have faded.

It's not necessary to make cirrus clouds parallel to your horizon when they appear in a drawing. Slant them slightly for more interest.

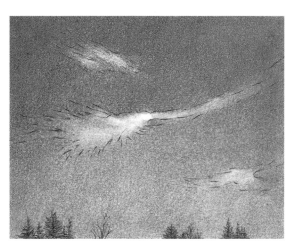

Preliminary Sketch
The preliminary drawing (in HB charcoal pencil) shows the positioning of the elements. The foreground is kept simple. You do not want to distract from your main interest — the cirrus clouds.

Step 1
On a separate piece of paper, use a 2B charcoal pencil to shade the whole box. Use a stomp to smooth out the charcoal, giving an even tone. Wipe lightly with a piece of tissue to remove some charcoal from the bottom third of the box, creating a horizon — dark above and lighter in the distance.

Step 2
Place the preliminary sketch under the shaded box. Use a light box or a window with good light to trace it lightly with white chalk. Use a kneaded eraser to gently remove charcoal, shaping your cirrus clouds.

Step 3
Continue removing the charcoal, keeping in mind that cirrus clouds are fine, delicate images. After you have captured the feeling you want, add just a touch of white pastel for that icy sparkle. Add your foreground and you are finished.

ALTOCUMULUS

Altocumulus clouds also appear in a wide variety of forms, and they are often associated with other cloud types, such as altostratus or stratocumulus. The most memorable formation is the flattened, globular masses lined up in rows resembling a flock of sheep. They can range from bright white to dark gray, depending on the amount of moisture they are holding. As they build into layers, they usually indicate approaching thunderstorms.

Preliminary Sketch

The first step is the sketch—an interpretation of this type of altocumulus clouds. Remember, the photo is for reference only. Do not attempt an exact duplicate.

Start by roughly indicating the cloud shapes. Look for the pattern and pick up the flow, the wavy lines, the cotton puffs. The patterns are the keys. Look for them, then add your values.

Step 1

Next is the application of background tone. I used a 4B charcoal pencil to lay in the overall value. This was smoothed out with a felt stomp to remove still more charcoal. I then used a chamois stomp and facial tissue to create the dark-and-light cloud area, creating a feeling of texture.

Step 2

Begin lifting some tone from the background with a kneaded eraser. Keep in mind the shapes and design. Remember to wipe the eraser on a piece of scrap for maximum lift. Keep your clouds soft with no really hard edges.

Step 3

Continue to shape the clouds, but do not overwork them. Leave something for the viewer to imagine. Use your sketch to stimulate your thinking. You can add the few trees or leave them out. The drawing will work either way.

STRATOCUMULUS

Stratocumulus clouds cruise in the lower atmosphere. These globular masses or rolls of clouds are layered one over the other. They resemble chunks of soft cotton but are gray with dark bottoms. The clouds may be arranged in groups, lines or wave-like masses; the layers may be thick or thin. A thick layer will be made up of rolls of large, dark clouds or rounded masses that resemble waves.

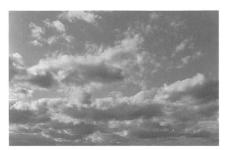

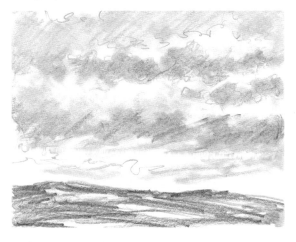

Preliminary Sketch

After trying numerous thumbnails, this is the composition that I developed.

I used a 6B pencil for the cloud shapes and rubbed it around with a tissue and stomp. The mountains were suggested with a dark wash and aqua pencil, with no water.

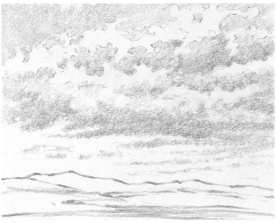

Step 1

Next I resketch a more accurate picture of the cloud shapes and the outline of the mountain. With a 6B graphite pencil, I lay in values. The top of the sky is kept light to hold the shapes of the clouds. I continue this tone to the bottom of the cloud formation, leaving white paper for the clouds. Then I add more tone to the lower part of the clouds.

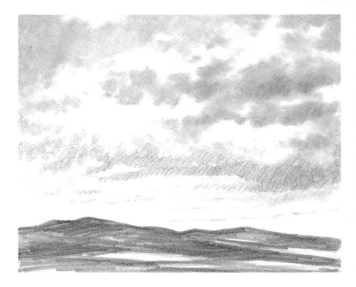

Step 2

Start blending tones with a felt stomp, facial tissue or cotton swab. I do not recommend the use of fingers because the oil from your skin can prevent smooth layering of the graphite.

Use a kneaded eraser to remove graphite and to shape the clouds. If you find that you need some more darks, add tone with your pencil and blend it with your stomp as before. Finally, add some darks to the mountain range.

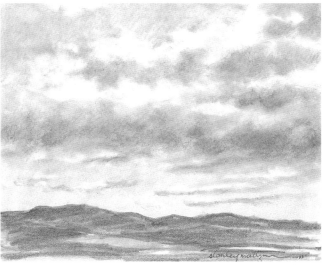

Step 3

See how the shapes have changed by manipulating the white areas with the kneaded eraser? Soften the tops of the clouds, and every so often come back with a little touch of dark on the top of the clouds. This will give the clouds more definition. The important things to remember about stratocumulus clouds are the soft fluffy tops and the flatter, darker bottoms.

CUMULUS

Cumulus clouds are fair-weather clouds. Like stratocumulus clouds, they drift in the lower atmosphere. A distinguishing characteristic is the flat, nearly horizontal, dark base and the cotton-ball top with edges that always seem to be evolving or growing vertically. Cumulus clouds usually appear in the morning and practically dissolve by evening. They offer beautiful shapes to include in your composition.

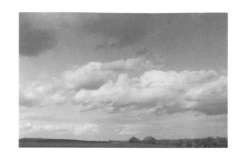

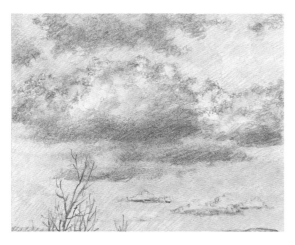

Preliminary Sketch
To arrive at this composition, I worked on a piece of white vellum that you could see through. I moved, added and deleted my elements with each successive sheet till I arrived at this happy decision.

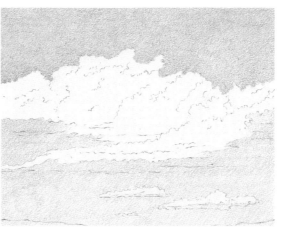

Step 1
On my Strathmore drawing paper, I laid down the initial tone of the sky with a 4B graphite pencil, then I added a second layer with a B pencil. These values were rendered with the circular shading method discussed in chapter two. Again, notice that the tone is lighter near the horizon than overhead. These changes in values, as well as the smaller, distant clouds, give your picture perspective.

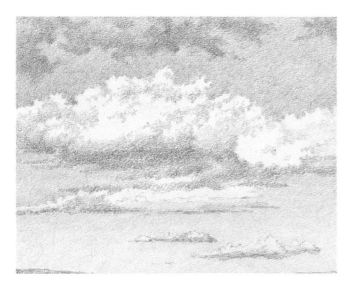

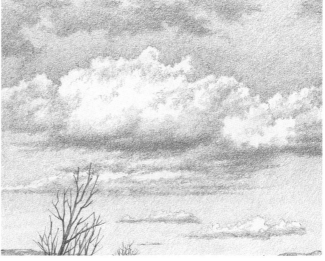

Step 2
I start to give the cloud mass some dimension and add a little tone to the mountain and distant cloud shapes, but not too much as they are to remain in the background. I establish the darkest dark in the main cloud shapes, which guides me as to how dark the receding clouds and mountain should be.

Step 3
Once the shapes are pretty well worked out, it is time to give them more definition. I establish the darkest dark under the large main cloud, then add a little more tone around the other cloud shapes, making some clouds recede and others come forward.

CUMULONIMBUS

Cumulonimbus clouds generally produce heavy thunderstorms, and if they climb high enough in the atmosphere, their precipitation will be snow.

The base of this cloud is almost flat. Its color, gray or dark gray, is determined by the amount of moisture it contains. The top often takes the shape of an anvil. Cumulonimbus clouds are in a constant state of motion and change, making them challenging material for the artist.

Preliminary Sketch
This preliminary sketch has minimal detail. I was looking for a mood as well as indicating cumulonimbus clouds. The loose sketch suggests the type of cloud I want, while leaving me the flexibility to experiment.

Step 1
Without nailing down any detail, I suggest the shapes. A little tone is applied to indicate where some darks will be placed. I am still visualizing, still keeping loose, so that if I wish, I can push shapes and values around.

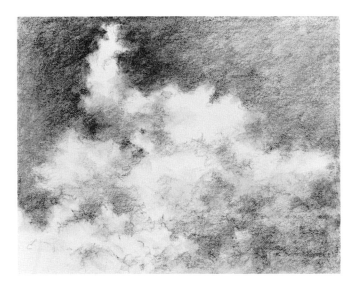

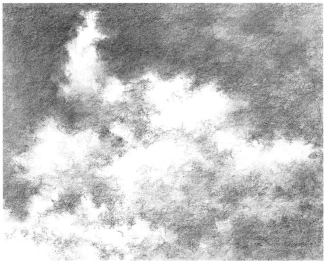

Step 2
I covered the background loosely with a 2B charcoal pencil. Some indentations were added to show the puffiness of the cloud formations. The darks were added with a stick of medium vine charcoal. Satisfied with the dark values, I dipped a flat ½-inch brush in water and pushed the charcoal around. Do not use too much water with this technique. You can create beautiful soft-gray values with residue left on the brush from dark areas.

Step 3
I was not quite satisfied with the values. More darks, painted with water, were added; then charcoal pencil was applied on top of this. The fresh charcoal on top of the painted surface adds an interesting texture and a freshness to the drawing. The paper I used was 4-ply 100 percent rag museum board.

INCIDENTAL CLOUDS

Have you ever worked for hours on a scene and wondered what was missing? You realize the picture needs something in the sky — nothing dramatic or earth-shattering — but some clouds are needed. Incidental clouds are shapes you can add to your sky to save an otherwise drab landscape.

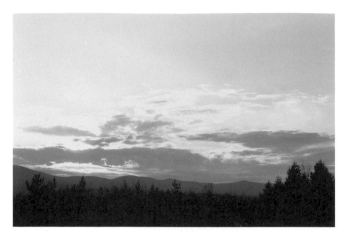

This is the view from my studio window, a sunset over the Catskill Mountains. It's a scene I have attempted to sketch many times.

Step 1

On a piece of buff-colored Canson pastel paper, I laid in the sky with a piece of soft vine charcoal and smoothed it over with a tissue. The tone for the mountain was added and carried through the foreground without details. My main concern at this stage was just to work in my values.

Step 2

The clouds were reworked with a stomp, dry finger and tissue to show more variations in the cloud shapes. With a kneaded eraser, I removed areas of charcoal to give the appearance of the sun setting behind the mountain.

Step 3

I again went over the mountain area with the tissue to remove just a bit more charcoal, as I wanted a definite difference in values between the mountain and the base of the clouds. With a 2B charcoal pencil and a minimum of pressure, I added to the top of the mountain a fine ridge line from one end to the other. Then, using the stick of vine charcoal, the silhouettes of the foreground trees were added. Notice the lack of detail. They are just shapes. The clouds overhead were softened at their base, and the drawing was completed.

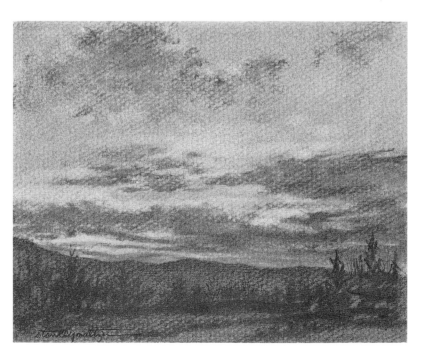

Incidental Clouds

Here's a scene in which clouds and landscape work together to make a picture. Neither one is outstanding, but if you were to take one away, there would be no picture.

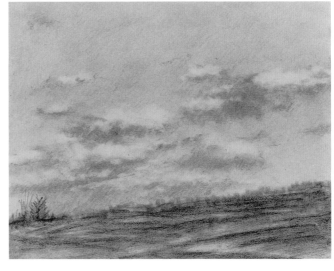

Step 1
Begin by applying a light tone with an ebony graphite pencil. Make it a little darker tone on top than at the horizon at the bottom of the sky. (This gradation creates perspective.) When you have the sky laid in, smooth it out with your stomp and tissue. Cover the whole picture with a tone. Since there is nothing specific to draw around, it is easier to pick out the light areas with your kneaded eraser than to try putting the tone around each cloud. The result is a nice, even background color.

Step 2
With a kneaded eraser, take out tone to create the light, fluffy parts of the clouds. Then add the darks, being careful not to overwork cloud shapes. Add some foreground elements to see how compatible the terrain will be with the sky.

Step 3
The clouds were accented with more darks, which makes the whites brighter. The trees are shapes with a minimum suggestion of trunks and limbs. It is not necessary to have a lot of detail; the shapes tell the story. The drawing was executed on Arches 140-lb. hot-press watercolor paper.

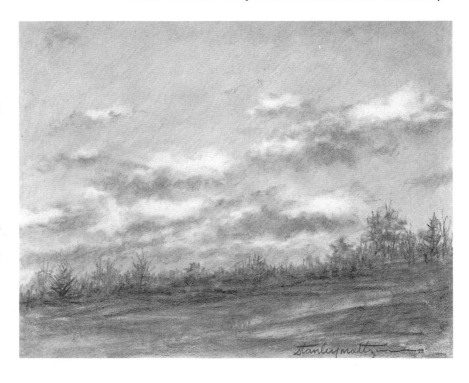

DRAMATIC CLOUDS

You can create all kinds of drama with clouds: clouds flying across the sky, light rays coming from behind a cloud, dark clouds massing together before a storm and dispersing after the storm.

The clouds are usually there.

What you do with them creates the drama. Strong dark-and-light values and the energy created by your pencil strokes make clouds dramatic. Keep your cloud shapes simple as you work to capture the mood.

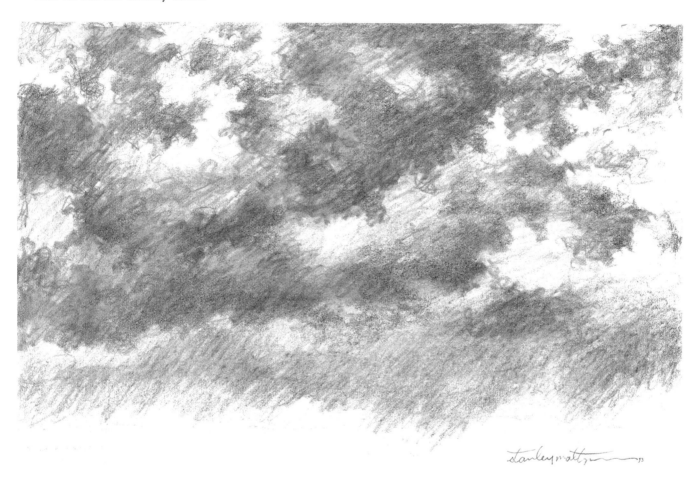

Dramatic Clouds
This sketch was worked with a soft, water-soluble pencil on 140-lb. Arches hot-press watercolor paper. All values are laid in until I achieve the mood I wish to express.

Next I take a soft brush, dip it in water, wipe it lightly on a rag, and starting from the top, draw the brush from left to right. After the entire sketch is wet, I come back again with a moist brush and start painting and pushing the graphite around. Try not to stay in one place too long. Move around the paper, rinsing and wiping your brush often to keep from dragging your darks into the light areas, which will tend to muddy things. Water-soluble pencils allow you to work your pencil into a wet area, rework a drawing when it is dry, and erase or lighten to recapture white areas that have been lost.

DRAWING NATURE

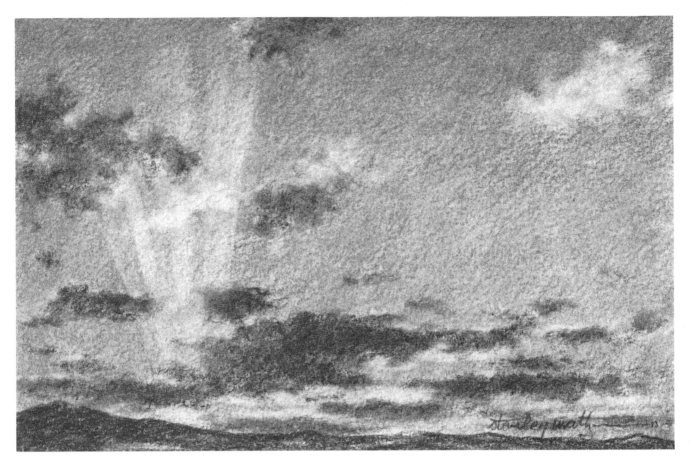

Dramatic Clouds

The greatest drama in the sky seems to take place at sunset. This charcoal sketch of a sunset was executed on a sheet of mould-made Somerset textured paper manufactured in England.

First, I lightly drew the clouds in position together with the mountain. Then, with a medium stick of vine charcoal, I laid a tone over the whole background. I smoothed it out with tissue and stomp to create that placid look in the sky that you see at sunset. I then took a 2B charcoal pencil and put in the clouds and mountain, slightly modeling the clouds with finger and stomp for texture. A kneaded eraser was used to lift charcoal from the clouds for the backlighting. To get the effect of the rays, I used a piece of paper with a straight edge and lifted tone with a kneaded eraser. With the stick of vine charcoal, I gently touched the clouds here and there for more dimension. The mountain was made a little darker, and the drawing was finished.

CLOUDS AS CENTER OF INTEREST

To create pictures with clouds as your center of interest, use a low horizon. This helps give you maximum display room for your clouds and less distraction if you include a landscape. Clouds that display strong contrast, motion, different patterns and shapes, perspective, or the atmospheric condition of the day will all create a strong center of interest.

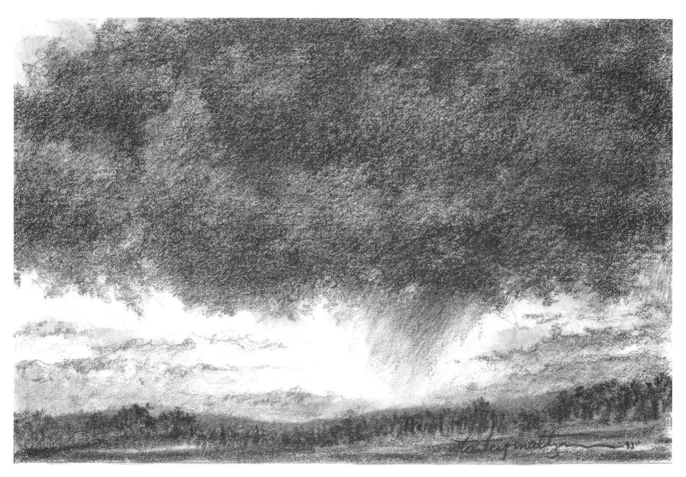

Clouds as Center of Interest

The challenge here was how to capture the tumultuous storm clouds in all their excitement. There is so much activity with the clouds in constant motion; the best approach is to pick out a general pattern and simplify.

With a 2B charcoal pencil on a piece of 4-ply, 100 percent rag museum board, I lightly sketched the cloud shapes, the background and the foreground. I used a 4B to apply tone to the storm clouds, going a little heavier around the edges. I added additional tone to the clouds with a 6B charcoal pencil, modeling until I was satisfied with the shapes. Then with a damp bristle brush, I modeled the clouds some more.

To capture the rain shower, I dragged a semidry brush down from the cloud. I finished the background and foreground, keeping them simple.

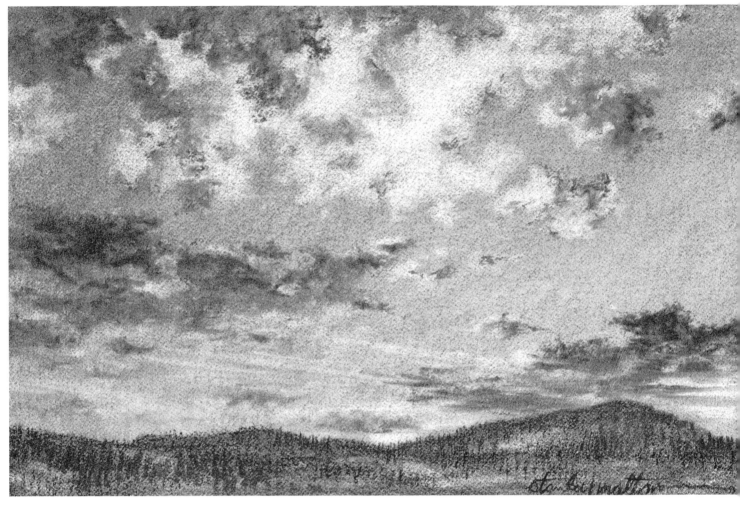

Clouds as Center of Interest

The problem I had to work out in this sketch was to include some landscape but not have it interfere with the center of interest—the clouds.

The composition was lightly sketched on a sheet of 2-ply Strathmore bristol with a 2B charcoal pencil. The background tone was added with a 4B charcoal pencil, then stomped to even it out. Wherever there were white clouds, I stomped just past the outline I originally indicated. This allowed me to keep an even tone for the sky. (You can always come back with the kneaded eraser to pick out whites where needed.)

After reshaping the white clouds, dark clouds and shadows were added with soft vine charcoal. I used an uneven stroke to create texture. The mountain was shaded with a 2B charcoal; the trees were added with a 4B pencil and soft vine charcoal.

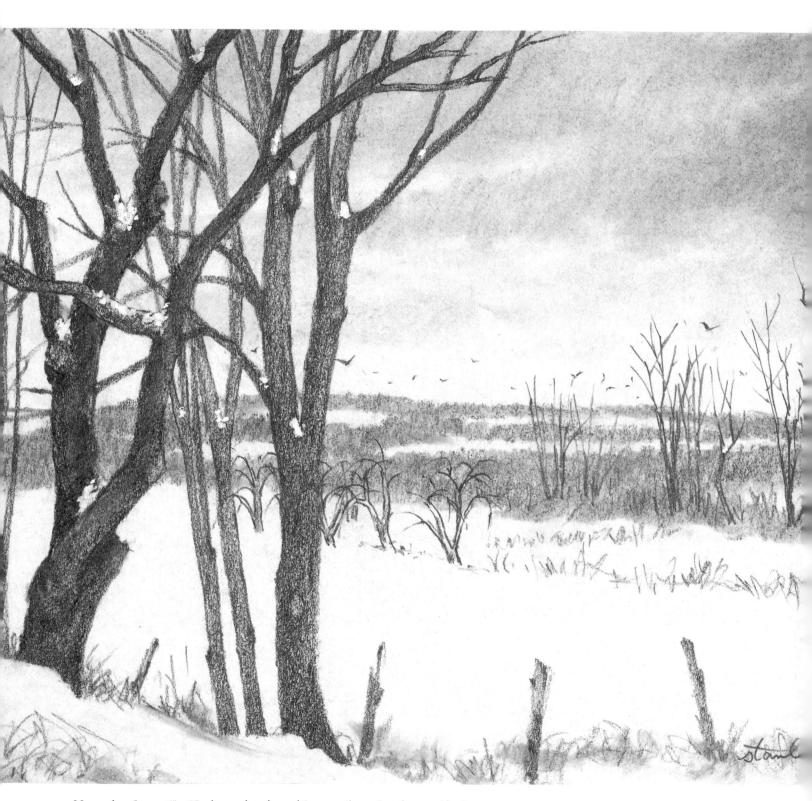

November Snow, 6″ × 9″, charcoal and graphite pencils on Strathmore Alexis paper.

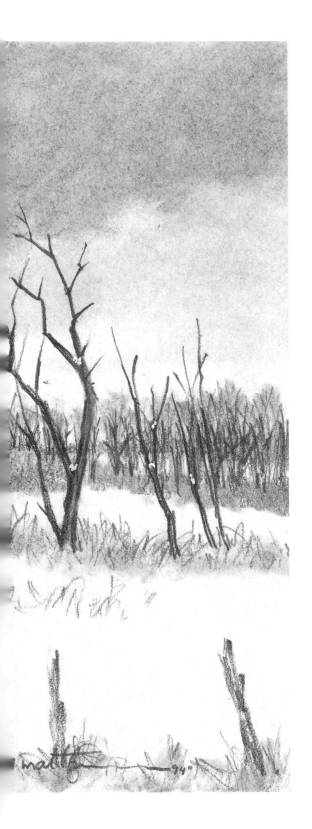

Snow

Snow has always been one of my favorite drawing subjects. When you go out to do winter sketching, look for a pattern such as a plowed field, or shapes like rolling hills to create a design. Avoid making simply a photo-like picture; your composition should go beyond a photographic imitation. Create abstract shapes with landscape elements such as fields, trees, houses and winding roads. These shapes are easier to recognize in winter landscapes and will enrich your drawing with better design.

TECHNIQUES FOR SHOWING LIGHT SNOW

For the light dusting of snow in drawing *A*, I used a 2B graphite pencil to sketch an outline of the tree trunk and limb. A light pencil line indicates the upper edge of the snow. The shading of the trunk and limbs was done with a 6B graphite pencil worked up to the snow line. A few darks were added under the snow to indicate thickness and add to the impression that the snow is lying on top of the bark. To intensify the feeling of light snow, a small amount of snow was left at the crotch of the foreshortened limb for balance and interest. The paper chosen for this drawing was Rives BFK, which has very little tooth to the surface, giving me the texture I desired.

Drawing *B* was worked on a piece of Arches Ingres paper, a laid paper that I specifically chose for its textured surface. I dragged a 4B charcoal pencil with a flattened lead across the surface to give the appearance of light snow covering the ground. Showing some grass and spots of snow-covered ground creates an interesting pattern. The dark, wooded background is kept simple so as not to distract. The snowflakes were induced with a bristle brush and white gouache water-based paint. Be careful not to overdo this process. A few spatters tell the story.

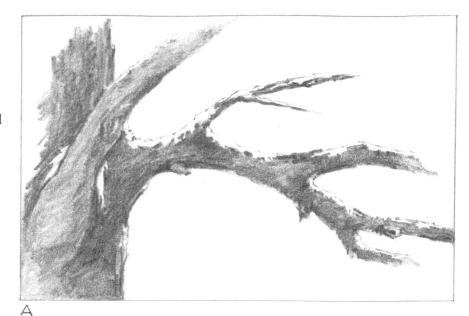

A

B

DRAWING NATURE

TECHNIQUES FOR SHOWING HEAVY SNOW

This is the same tree as in *A* but with a heavy snow. I proceeded as before with a 2B graphite pencil to sketch in the trunk and limbs, but this time I left more white space to indicate the heavier snow. Notice that I've included snow on the trunk of the tree. When you have a heavy snow, blowing wind produces this kind of buildup. The dark shading was done with a 6B graphite pencil.

Drawing *D*, containing the same elements as drawing *B*, shows the difference between a light snow and a heavy snow. The background, which was darker before, is now lighter to show that the woods have been sprinkled with white snow. The limbs have more snow on them, and their undersides are a little lighter in value to show reflected light from the snow. Notice the buildup of snow on the bark and at the base of the old pine. The trunk was made darker for design impact and to show that it is wet and is darker when you have heavy snow. A few lines in front of the tree, and the drawing is completed. I used Rives BFK paper with 2B and 4B charcoal pencils.

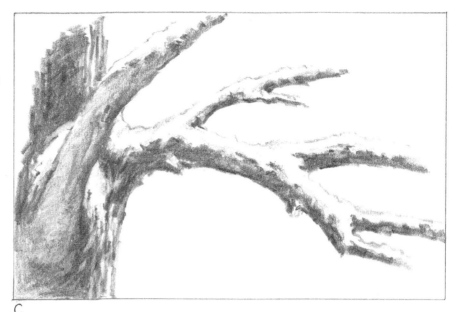

C

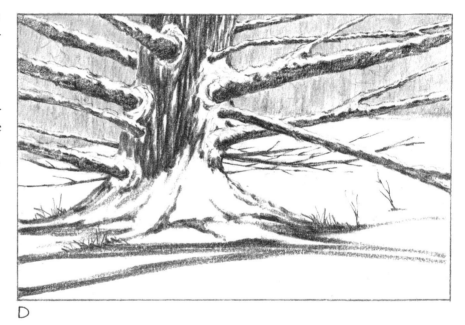

D

DRAWING A SNOWY LANDSCAPE

Preliminary sketch
This sketch was done on a piece of vellum layout paper. A 2B and a 4B charcoal pencil and a piece of soft vine charcoal were my drawing tools. These preliminary studies will get your thoughts down on paper, so you can develop a satisfactory composition before starting to work on your finished drawing. As I neared completion, I realized that I needed more snow on the left side. A piece of white pastel enabled me to create snow to my satisfaction.

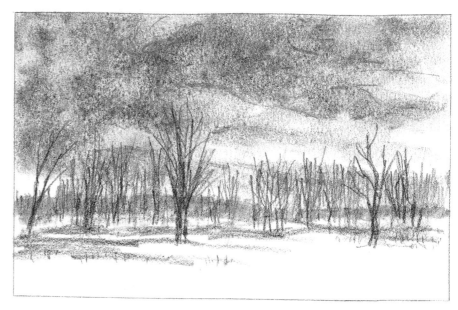

Step 1
This is a rough indication to help guide me in the placement of elements in the drawing. There's no sense putting in the foreground trees until the sky is finished, as they would only disappear as I model the clouds.

Step 2
I sketched the clouds in with a piece of soft vine charcoal. Then I blended with the stomp until I had the suggestion I was looking for. This was sprayed very lightly with workable fixative. When dry, a B Wolff's pencil, which is a carbon-based pencil, was used to emphasize the cloud shapes. The fresh, black pencil applied on top of the stomped charcoal base made an interesting texture. At this stage, the patterns of the snow and land were indicated.

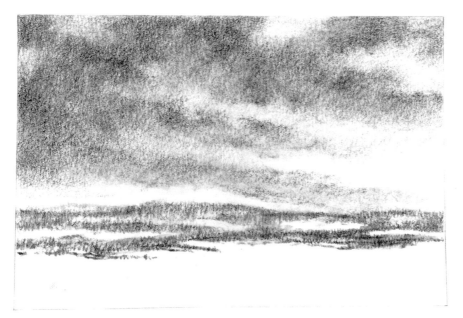

DRAWING NATURE

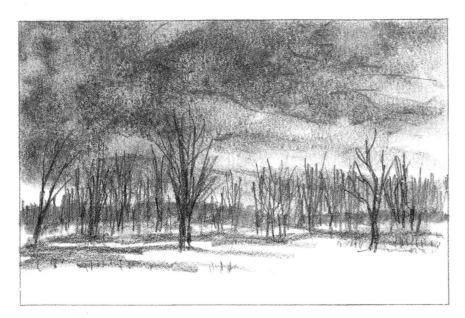

Step 3

I begin to build up the land shapes. Every so often, with a fine point on my pencil, I make some small vertical lines where the land meets the snow. The lines should be irregular, of different sizes and go past the land shape into the snow. This gives the appearance of weeds or shrubs sticking up through the snow. Use a B pencil to work the background trees and parts of the landscape, alternating with a 2B or a 4B pencil to acquire the values you need. I work the background lighter before adding foreground trees and land shapes. This way, I layer elements. The darks in the foreground cover the lighter background values, which gives the picture perspective.

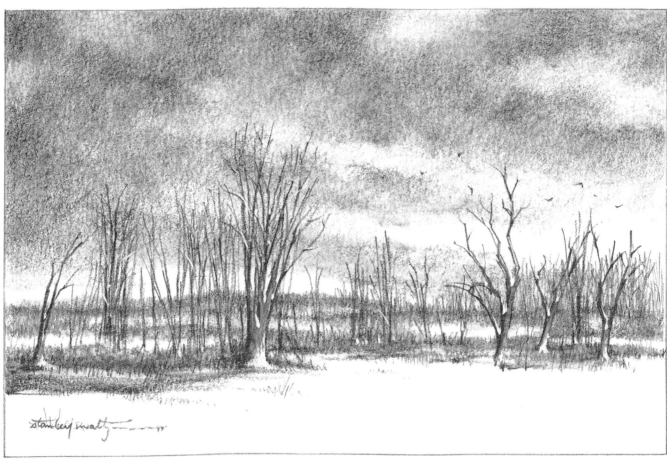

Step 4

Notice the changes that occurred from the preliminary sketch to this finished drawing. The sky is basically the same except for the addition of some frolicking crows. The landscape was changed to include more snow between the land shapes, and some snow was added to the trees with white gouache. Basically, the positioning of the trees is fairly close to my original conception.

A word of caution: When placing flying birds in your landscape, do not overdo. Incorporate them with the overall design so they don't look like an afterthought.

MOUNTAINS WITH SNOW AND TREES

Snow-covered mountains present a variety of shapes and patterns to compose beautiful winter landscapes. I can see part of the Catskill Mountains from my studio window, and when I look at the skyline, I see a line of trees silhouetted against the sky that, to me, resembles the stubble of a beard (Sketch A). Mountain ridges with trees offer many opportunities for creating interesting shapes and designs, but be careful not to make ridges parallel to each other or make trees all alike. Vary your angles and shapes to create more interest.

On a trip to Yellowstone National Park, I sketched this mountain range (Sketch B), which was different from my mountains back home. It had these beautiful snowy peaks with thousands and thousands of trees breaking through the snow. Notice how the tree shapes were used to create designs across the mountain range.

In the close-up view of Hunter Mountain in New York state (Sketch C), I darkened the tree line on the left, gradually lightening it as it moves to the right. As I work to the foreground, shapes get larger and darker, creating a sense of depth and perspective.

In all three of these sketches, the sky was first shaded, then stomped. I used an HB graphite pencil on a sheet of Strathmore sketching paper. All were executed with the same pencil, demonstrating what you can accomplish with one pencil, varying the pressure as you work.

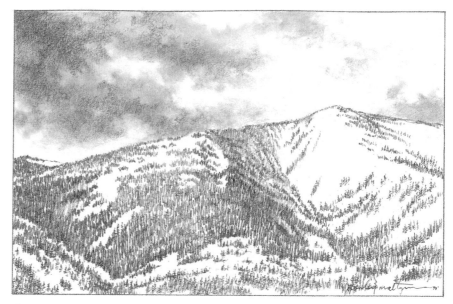

A

B

The trees were indicated with short lines at the peaks and upper parts of the mountains. The tree-lengths were varied throughout the picture. A few identifiable pine shapes are spotted throughout, creating the illusion of a mountain range covered with snow and pines.

C

It is not necessary to include every limb of the trees; the vertical lines spotted around give the appearance of many trees on a snow-covered mountain.

SNOW ON TREES

The way you portray snow on trees will tell the viewer if it was a heavy snow, a driving storm or just flurries. A driving storm would show more snow covering the trunk and vertical wood of a tree; a light snow would show much less.

You can also tell a story with your winter sky. In the drawing below, we see a pine tree in a field after a snowstorm. The gray sky, with a little white showing, tells us the storm is over and the sky might be clearing. I wanted to capture the mood created when the sky and the land take on a warm gray appearance after a storm. Except for the large pine, all the elements have a soft look accompanied by the kind of quiet found in fields and woods.

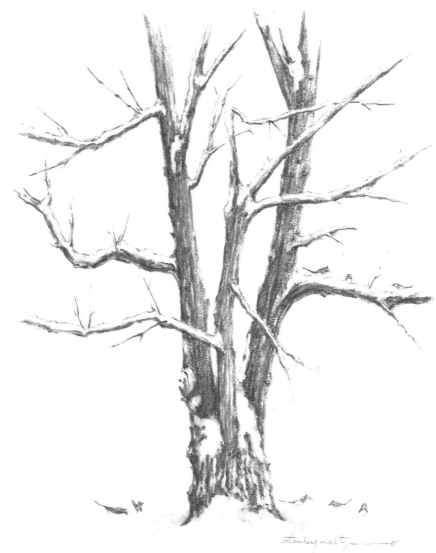

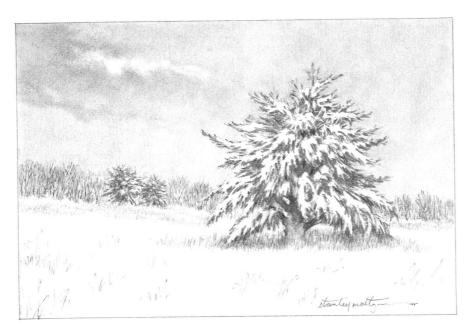

This locust tree was sketched with an aquamedia pencil. Then I went over parts of the tree with a wet brush, blending the pencil marks into soft gray tones. When the paper dried, I went over the drawing again with the pencil, accenting the darks and adding more character to the wood. The paper was 100 percent rag, 4-ply museum board.

To portray a pine covered with heavy snow, find the pattern created by the snow on the limbs and the dark separations between them. The snow is the white of the paper, and a B graphite pencil was used for the darks of the tree. Notice the spaces left between the trees in the background woods, giving the feel of a heavy snow. An HB pencil was used for the background woods, as well as the weeds under the tree and sticking out of the snow.

DRAWING WINTER LEAVES

The next time you take a walk after a snowfall, notice the leaves lying in the snow—some partially buried, others lying on top in various shapes and positions, such as an oak leaf curled up like a beckoning hand. But how do you get a pile of snow into the studio and keep it from melting? You could take photographs, but if you want to be more intimate with your subject than photography allows, there is a solution.

First, go outdoors and collect a large variety of leaves. Bring a large paper bag so the leaves will not be crushed. Two dozen leaves will give you enough choices for your composition. Also, you'll need a small box of white soap powder (make sure it is a powder, not flakes) and a 14″ × 17″ piece of heavy illustration board. Pour some soap powder on the board, but keep some in reserve. Then with a small brush, shape the "snow." Make little hills and valleys, keeping it irregular like snow would be in a wooded area.

Arrange your composition one leaf at a time. Use a spoon, spatula or wide brush to push the "snow" around. Create the impression that your leaves are part of the forest floor or a snow-covered field. When your leaves are arranged, take a spoonful of powder, and holding it about six inches away, gently tap the spoon, creating your own "natural" snowfall. You might also try dropping some leaves on top of the snow. They might land just where you want them.

To start your drawing, you can begin on your good sheet of paper, or you can work out the drawing first on a piece of tracing

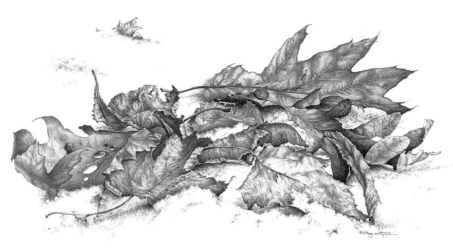

Winter Leaves, 18″ × 22″, Wolff's pencil on Whatman paper. Collection of Brenda Shears.

Brush white soap powder into little hills and valleys to form natural-looking snow.

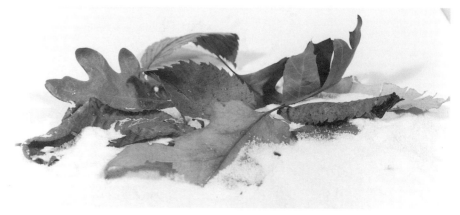

Arrange your leaves into a pleasing composition, then sprinkle a little powder over them for a snowfall effect.

DRAWING NATURE

paper. If you choose the latter, you then transfer the contour sketch to your working sheet and start shading. The beauty of using tracing paper is that if you want to make changes, you can lay a clean sheet of tracing paper over what you have and redo the section or sections you wish to change.

The contour drawing (right) was drawn extra dark so that you could see the line. Normally I keep the line light and let the various tones hold the edge. Keep your preliminary sketch light to avoid that hard-outline look.

Once you've transferred the sketch to your working sheet, lightly add the main lines to the leaf. You do not have to include every line, just the center line with the larger offshoots. The rest you will simulate with your rendering. Pick out the lightest leaf, and with an H or HB graphite pencil, put in an overall tone to the leaf. Come back again with the same pencil, adding ripples

and veins. With the next degree of graphite, add more definition and darks. Remember, you can lift tone with your kneaded eraser.

After you finish one leaf, use the circular method to put a light tone on all leaves to guide you as you add additional tones to make one leaf darker, one leaf recede, and another come forward. Add a few holes or mold marks, but

keep it simple; you just want to give the leaves a touch of reality.

Make the snow with light circular and wiggly lines, adding the dark shadows last.

Remember to work your darks against lights and lights against darks. Use a sharp point to get more control of the marks you put on the paper, and keep a sheet of paper under your hand as you work to prevent smearing.

You can work out your contour drawing on tracing paper, then transfer it to your good drawing paper when you're satisfied with it.

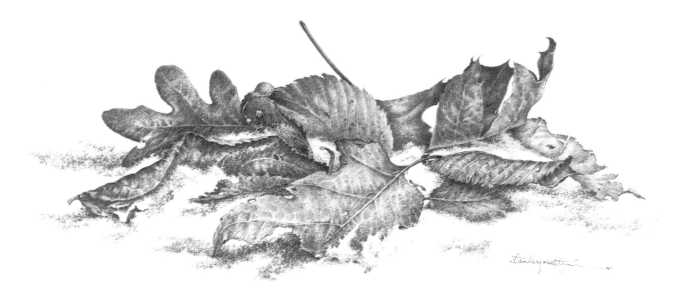

Winter Leaves II, 18" × 22", graphite pencil on Whatman paper.

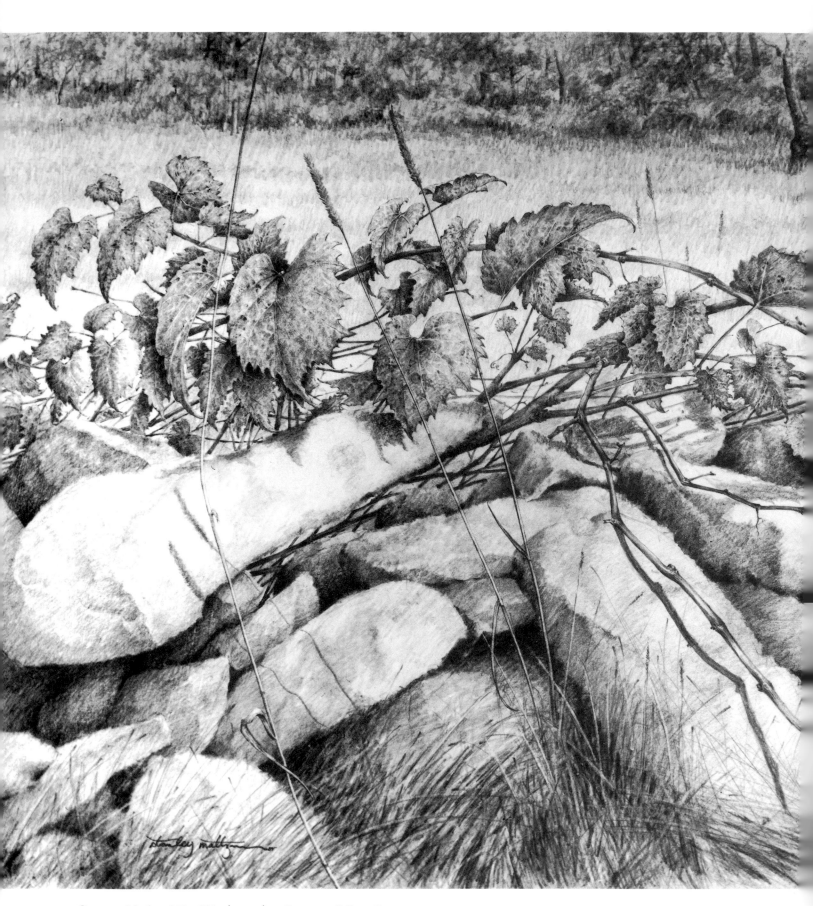

Country Marker, 22″×30″, charcoal on Japanese (Misumi) paper.

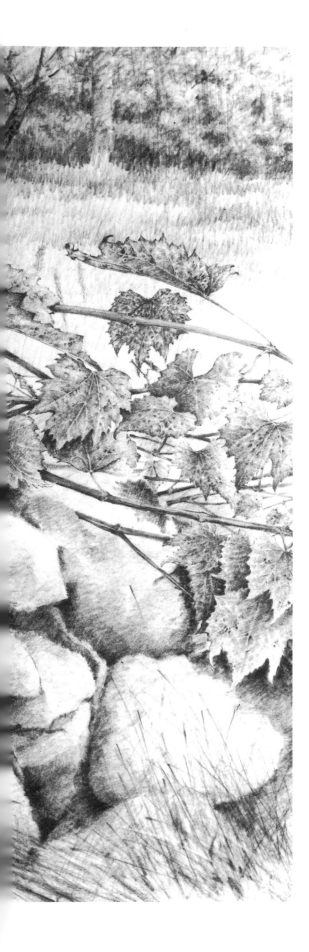

Barns, Grass, Rocks and Water

At one time or another, you will wish to include other elements—such as barns, grass, rocks or water—in your landscape drawings. It's not enough just to have them in your picture, but careful consideration should be given to whether one will be the center of interest or a supporting character. Therefore, a knowledge of their construction and characteristics is important for drawing successful landscapes.

BARNS

Of the many things on the endangered species list, barns must be near the top. The next time you are in the country, try to get permission to look inside an old barn. If you have an appreciation for craftsmanship, these architectural wonders will appeal to you. Whether it be the hand-hewn beams, the peg construction, or the beautiful patina of the boards on the outside, you'll find something to admire. These picturesque constructions have naturally attracted artists as elements for landscapes or as close-up studies. The following drawing techniques will help you give barns the character they so richly deserve.

PLACING BARNS IN THE LANDSCAPE

Here we have two versions of a scene with the same elements: a barn, a silo and a tree sitting in a field of grass. The first is rendered fairly well, but does nothing for the viewer. There is nothing going on, no story to draw the viewer's interest. The placement of the main elements and the uninteresting field add up to a monotonous picture. The barn is fine, but it needs help.

In the second version, the barn has been repositioned. A simple sky, a background of trees, a plowed field, fence posts and grazing sheep all add interest. Note that the plowed field, the posts, and the angle of the grazing field all point the way back to the barn. The barn is not overpowering, but it is still an important part of a picture that has a story to tell.

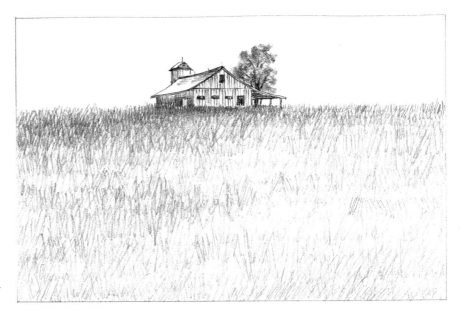

Mistake

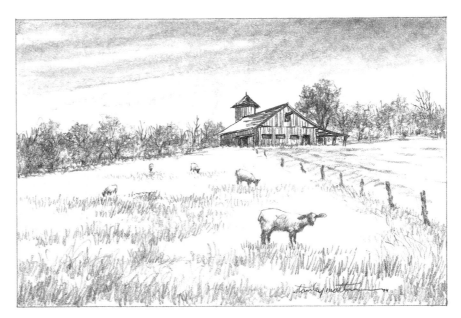

Improvement

DRAWING BARN SIDING TEXTURES

Step 1

To create on paper the beautiful sculptured wood that you see on barns, select a paper with a textured surface, such as Strathmore 400 Series regular drawing surface. Take a 2B charcoal pencil with the charcoal sanded to a forty-five-degree angle as shown. Apply the charcoal with vertical strokes without concern that some strokes will be darker than others. Remember, you want to create rough-looking siding that has been open to all of nature's elements for years and years. This is one time that neatness does not count.

Step 2

Once the surface is covered with charcoal, take a stomp and again, with vertical strokes only, run the stomp up and down lightly to create a gray value. Do not smooth the charcoal—that would eliminate the texture you are striving to achieve. Next, add the board widths with an HB or a B charcoal pencil. Use only vertical markings, as illustrated. Boards on this barn usually varied in width, since the wood was gathered from whatever trees were available at the building site.

Step 3

Start creating the wonderful knots, knotholes and irregularities of the boards. Of course, you want to include the cracks and crevices that snow, rain and sunshine have sculpted over the years. Make some of the lines thick and others thin to account for expansion and contraction. Create knots randomly, and surround them with crack lines, which run from the top of the board down to the knot, where they bend around the knot and continue their course downward. These lines should be of varying thickness and not necessarily parallel to each other. Take advantage of the natural variations in the paper, and add or delete tone to create all kinds of textures. Notice the shadow across the top of the drawing. You can still see some texture within the shadow area.

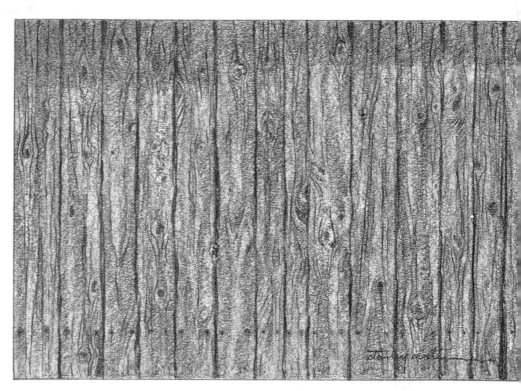

CAPTURING THE CHARACTER OF OLD BARNS

Most barns have a certain personality—something that gives them character and quiet dignity. Each person will draw these barns in a different manner, because each person will see and value different things.

The first thing to do when drawing an old barn is to forget about using a T-square, triangle or ruler. The freely drawn line, rather than the mechanically correct line, will add a great deal of warmth and personality to your drawing.

When indicating boards or siding, vary the thickness of the line to indicate spaces between the boards. To show age, make the bottom of the boards irregular with broken pieces missing. Draw the doors and windows hanging at an angle. In addition, windows can be shown with a crack or a pane of glass missing. Make the roof shingles irregular to show exposure and wear. Add unkempt grass, fence posts and other farm objects to the outside grounds.

All three of these barns were rendered with HB, 2B and 4B charcoal or graphite pencils on Strathmore 2-ply bristol.

The hanging and missing boards on this old barn tell a story of great age and hard use. Notice the variations in board width above the three windows.

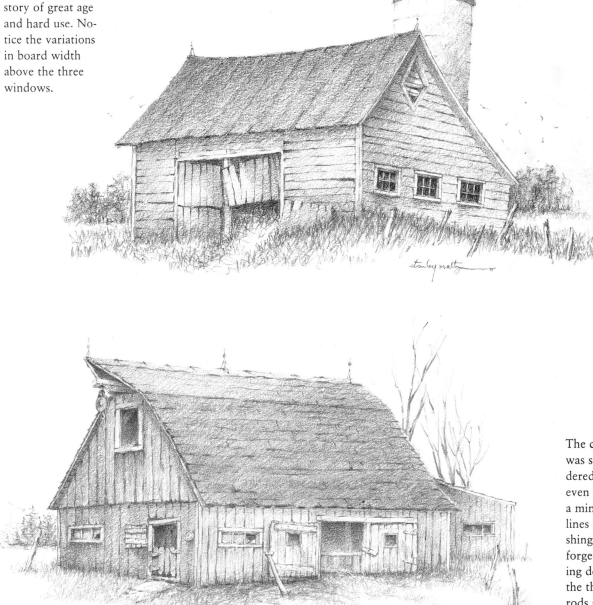

The curved roof was simply rendered with uneven shading and a minimum of lines to suggest shingles. Don't forget to add telling details, such as the three lightning rods along the roof's ridge.

DRAWING NATURE

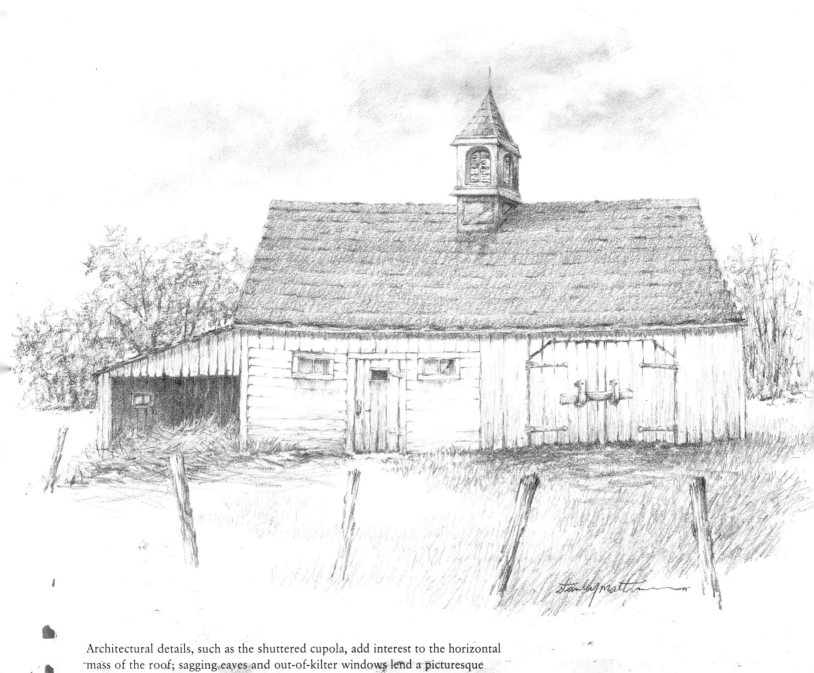

Architectural details, such as the shuttered cupola, add interest to the horizontal mass of the roof; sagging eaves and out-of-kilter windows lend a picturesque touch.

Kieszkiel Farm
12½″ × 18″
Charcoal on 2-ply
Strathmore
bristol.
Private collection.

In this drawing,
the strong sun-
light together
with the angular
shapes of the
buildings created
an interesting pat-
tern of lights and
darks. The shad-
ows held the barn
shapes with the
barest suggestion
of details. The tall
grass in the field
against the dark
values of the barn
made a pleasing
design — simple,
but strong.

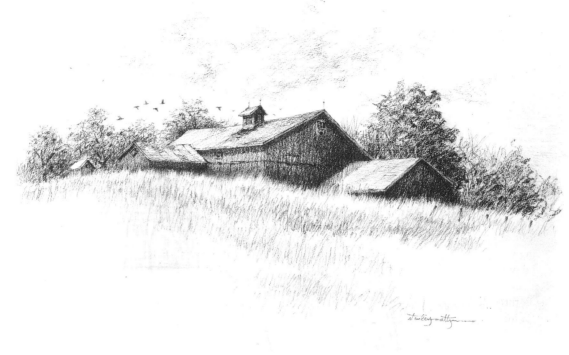

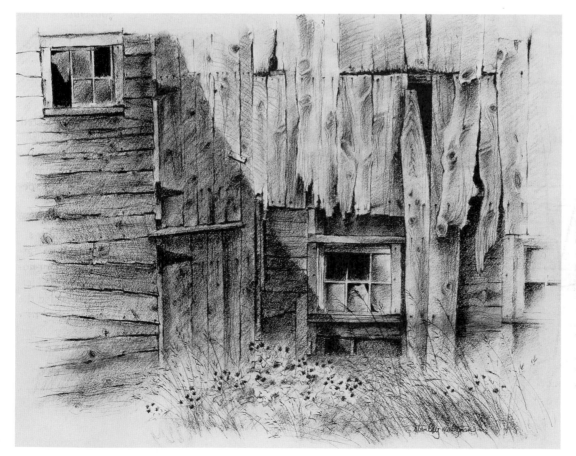

**Encroaching
Shadows**
18″ × 22″
Charcoal on
Whatman paper.
Collection of Su-
san and Douglas
Story.

This scene pre-
sented a wonder-
ful opportunity to
study barn tex-
tures. This is just
a small part of the
barn, but to me, it
makes a strong
statement. The
shadow empha-
sized the textured
boards in the sun-
light, creating all
the dramatics I
wanted.

Weather Indicator
23″ × 31″
Charcoal on Japanese paper.

My search-and-sketch efforts were rewarded when I found these windows with an antique Coke thermometer nailed to the siding, giving me the basis for this drawing. I moved the bush for the purposes of my composition. The drawing was worked with ¼-inch charcoal leads in three degrees of intensity.

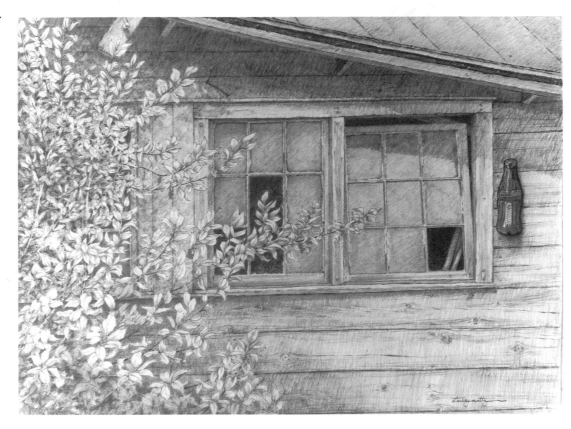

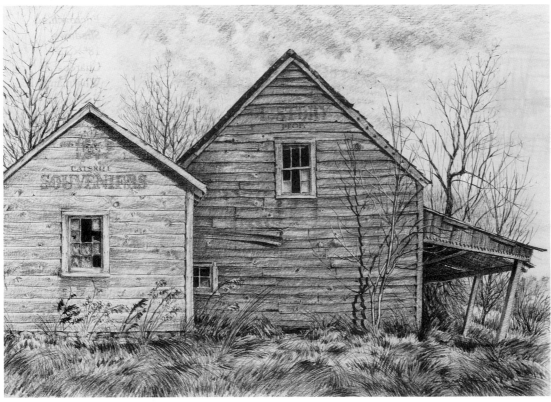

Souvenirs
23″ × 31″
Charcoal on Japanese paper.
Collection of Dr. Martin Koscih.

This scene offered countless opportunities for drawing old buildings, wood textures, decay and overgrown grass. The broken windows first caught my attention; then I noticed the faded lettering. I added the small window to break the strong line created by the edge of the lighter building. (Don't hesitate to add or delete elements if they will help your work.)

DRAWING GRASS

When including grass in your picture, consider what type of grass belongs there. Don't draw blades of grass all the same width, the same height, or leaning in the same direction. Unless it is a well-kept lawn, the grass will grow every which way.

The preliminary pencil strokes go in several different directions with overlapping and differences in height. Everything is kept simple at this stage, with no attempt to achieve various values or individuality.

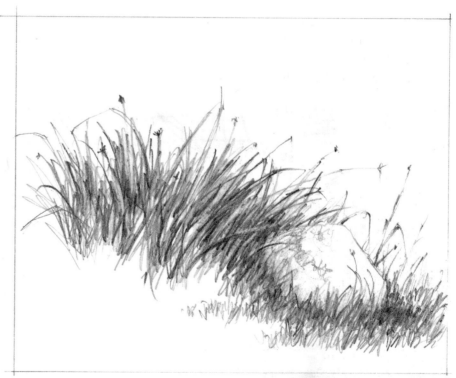

Using a sharp B pencil, without concern for your preliminary pencil marks, start overlaying your strokes slanting to the left, then right. Think "design" while doing this. Make some blades short, some tall, some curved, some straight, and some darker than others. Short, angular strokes denote weeds.

GRASS AROUND TREES

To draw grass around trees, start with an HB graphite pencil. Make the light strokes first to give an overall value of grass. Once the grass is indicated, work with a B graphite to add the darks of the trunks. Work some strokes into the light grass areas, giving them more shape and definition. Also add some random darks to the lighter grass values to create interest. Darken the grass to the left and right of the trees to create the appearance of roots. If you want some richer darks, take a 2B graphite, keep it sharp, and add your additional color.

GRASS AROUND BUILDINGS

Grass and weeds that grow around barns are different from the growth under trees. Here there are more weeds, probably

from the seeds in the hay. To capture this unkempt, weedy look, begin as you did the previous grass drawing. After drawing the barn boards, take an HB pencil and add your mixture of grass and weeds. Keep your strokes more irregular than before, with some strokes much lighter than others,

and some bending and curving to the left and right. You are creating mayhem, not uniformity. When you have formed your weeds, use a sharpened 2B pencil to add definition. Include a few dots on the ends of some of the larger weeds to indicate dried seeds or flowers.

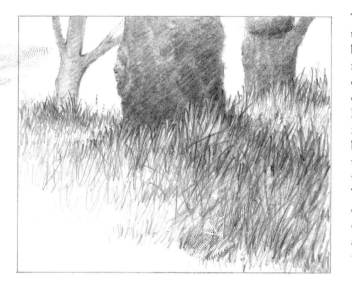

The small tree on the left has lighter bark; therefore, make the grass darker. The tree on the right is lighter than the foreground tree, but it has a value that still requires the lighter grass. The slight difference in the tone of the two trees adds perspective to the drawing.

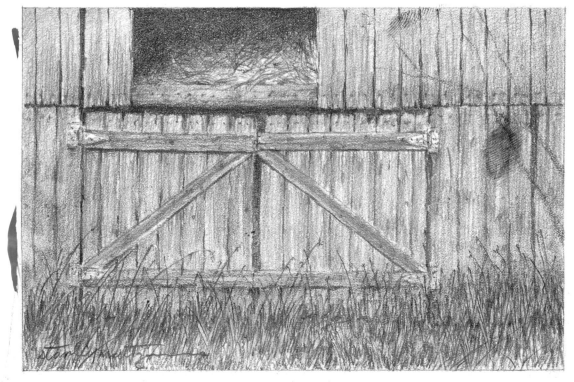

Irregular, chaotic strokes describe the weedy grass in front of an old barn.

DRAWING ROCKS IN A FIELD

Many artists are fascinated with rocks and boulders. Their odd shapes and various colors are fun to draw, but be aware that rocks should appear firmly anchored in the ground, not sitting on top of it. This is done by making the darker values of the rocks hold the shape of the grass, just as you did with the old barn and the trees.

In the composition at right, the shape of the large rock in the foreground leads your eye to the left, where the small rock, partially silhouetted, attracts and stops you. The grass leads you back to the middle ground, where the rocks again direct you to the left and the background.

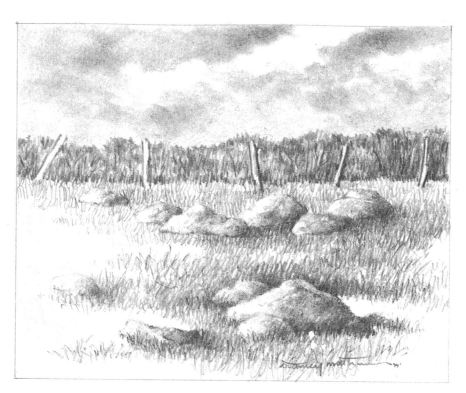

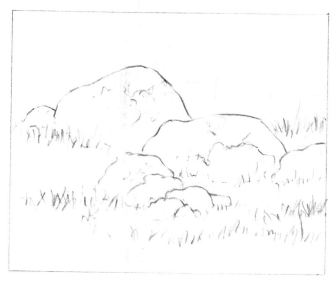

First, I make a quick thumbnail sketch to decide on an interesting arrangement of rock shapes and grass.

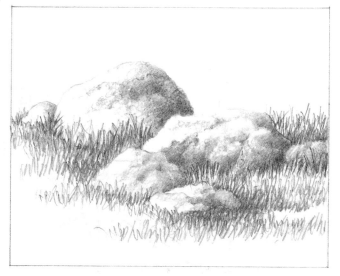

In my finished sketch, I start with a B graphite pencil to add tone to the rocks, letting the dark of the boulders hold the lighter grass shapes, and letting the darker grass shape the ground and the lighter rocks. To get some stronger darks here and there, I use a 2B pencil.

DRAWING NATURE

DRAWING ROCKS IN WATER

Drawing rocks in still or calm water gives you the opportunity to practice composing a picture that tells a story with values and shapes and a minimum of detail. These two drawings are good examples of how to say more with less.

The charcoal drawing on the right was started and finished with one pencil, a 4B charcoal pencil, on a piece of folio paper. This paper has a distinct texture, which helped me achieve the feeling of rippling water I wanted to portray. I wanted to capture the time of day when there is a little movement to the water and the bright sun creates a sparkle on top of it. If there had been no movement to the water, there would have been sharper-edged reflections of the rocks in the water. By softening the edges of the rocks' reflections, I created the feeling of gentle movement. Stomped charcoal was used to model the inden-

tations and shading on the rocks.

Below is a pencil drawing of the Catskill Creek, near where I live. Except for the few individual rocks in the foreground, the rocks were handled very simply: I drew various shapes with tone added and showed the rocks projecting as two masses. In this way, I was

able to eliminate detail and still have interesting shapes. The rocks' reflections in the background water are flattened to show perspective. More reflections of the rocks are included in the foreground. Reflections of the trees were added in the water to complete the drawing.

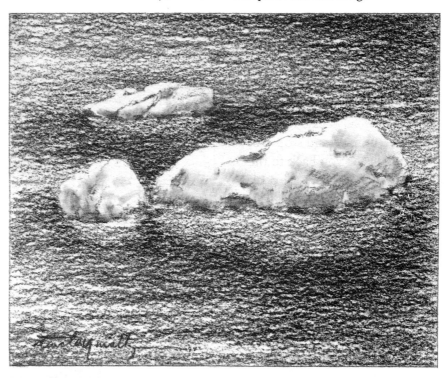

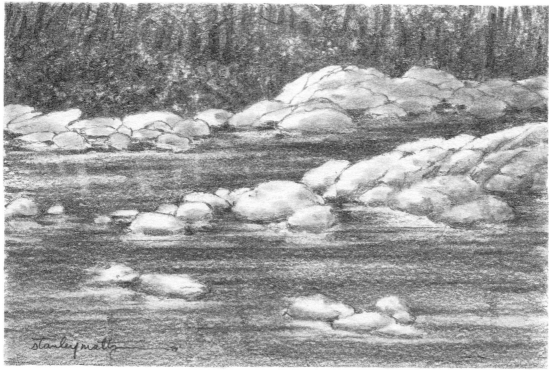

STONE WALLS

Did you ever take a walk in the woods when suddenly you were confronted, in the middle of nowhere, with a stone wall? More than likely, long ago, that woods was a farmer's field, and the wall was made from the stones some person accumulated while working that field. When the last glacier retreated, it left a bountiful gift — tons of stones that seem to grow out of the ground after each winter. To get rid of these stones, farmers removed them from their fields and sometimes used them to make stone fences and markers.

One type of wall consists of stones arranged haphazardly, one on top of another. Another type is as straight and sturdy as the day it was built. These stones were laid in an orderly fashion so that they fit together like a jigsaw puzzle. The weight of the stones on top kept the bottom stones locked into place. A stone wall properly built will outlive many other constructions.

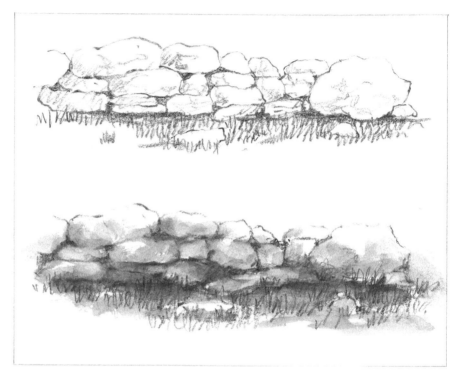

This sketch shows a well-constructed wall. With a water-soluble graphite pencil, first I made an outline sketch with a few indications of character, such as roughness and cracks. Then I took a wet brush (not soaking) and lightly painted the rocks with water to dissolve the pencil residue into a gray wash. (To make corrections, blot with a tissue or come back with clean water to remove areas you wish to change. Do not cover all the stones; leave some light areas.) After it dried a little, I worked back into the areas with pencil, emphasizing some darks between the stones and adding more texture for the grass.

Here, I added interest to an ordinary landscape by including a stone wall in the composition. The wall is kept relatively simple except for variations in the values, which give the rocks shape and individuality. These value changes also call attention to the wall and help guide the viewer through the picture. An HB and a 4B charcoal pencil were used on a piece of 4-ply museum board. With the sharpened 4B pencil, I sketched the picture with the values lighter than what I visualized for the finished piece. I then took a soft brush dipped in water and wiped it lightly over the charcoal.

When this dried, I added darker values and details with the HB pencil, making sure not to obliterate all the grays I had just created.

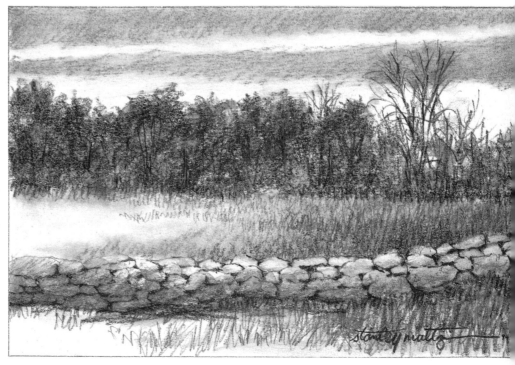

DRAWING NATURE

FENCE POSTS

Putting up fences is not an easy task, so people want them to last. Two of the most popular woods used are locust and cedar. These woods contain an oily residue, which resists the weather for years. Naturally, there are many variations to these simple posts, which, through time and the elements, have become, to my eyes, pieces of sculpture.

The post in the drawing *Remnants* was sitting alone in a field on an old farm in my hometown. I could not resist the beautiful patina of the wood, the pieces of wire and the weeds. Here was a story I had to put on paper. This was a charcoal drawing rendered with ¼" charcoal leads, then rubbed with a stomp and reworked with 4B and 6B charcoal pencils.

Look around for interesting fence posts in your area to draw. You will seldom find a model to sit so quietly for you!

Remnants, 30″ × 22″, charcoal. Collection of Robert Guba, Sr.

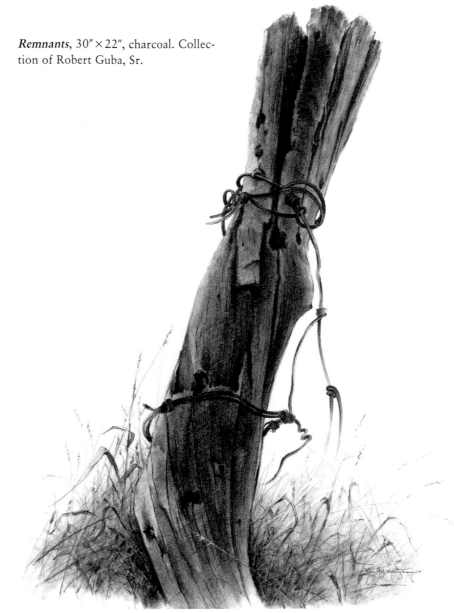

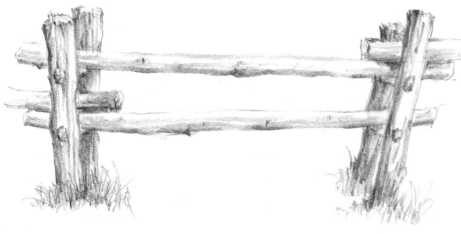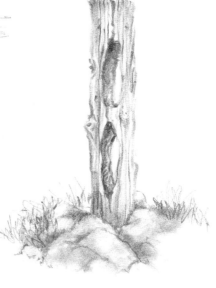

Here are two more examples of fence posts. They were rendered with 2B or HB graphite pencils on Rives BFK paper. Large trunks of locust trees were split with a series of wedges to the size of post needed. When augers were not available to drill holes in the posts, hot pokers were used to burn holes in which to insert the cross pieces, as shown in the drawing of the single post. Some posts were placed right in the ground, and others were held in place by rocks.

LAKES

Lakes supply an artist with a lot of good drawing material: water, animal life, rock formations, tree and plant growth, and other sometimes unusual natural wonders. In this small drawing of North Lake in the Catskill Mountains, I included the lake and an unusual phenomenon called a quaking bog. The bog floats around, gradually increasing in size through the years, and eventually becomes anchored as part of the land mass.

The large drawing was also inspired by North Lake. In both sketches, I created the impression of vastness by the dimension of the trees. In the small drawing, the trees were made small, which gives the illusion of distance. In the large drawing, I moved in closer to the trees and included a flight of ducks. In both pictures I deliberately excluded part of the lake, as I felt a part would be more interesting than the whole.

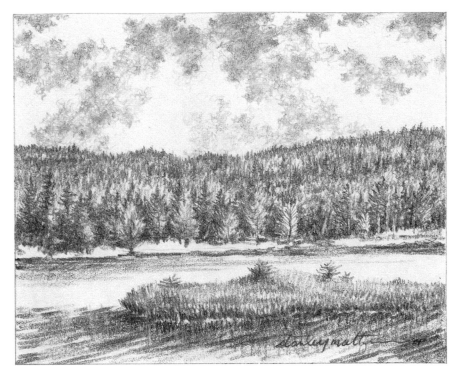

When drawing lakes, the important thing is to simplify. Look for the main flow, usually created by breezes or the wind, and indicate the movement with a minimum of line. These lines should be mostly horizontal in direction. Leave a thin line of separation between the water and the land mass. If the water is darker than the land mass, leave a thin white line. If the water is lighter, leave a thin line that is irregular and varied in thickness.

Reflections of foliage can be vertical or horizontal, and they should vary in value. Tree reflections, however, should be vertical only. Keep them simple.

DRAWING NATURE

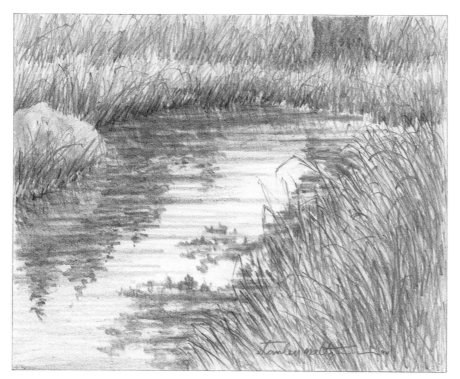

PONDS

Ponds are bodies of water smaller than lakes. They may occur naturally as a result of underground springs, or they may be man-made holes dug for any number of reasons. The pond environment catches the attention of many a landscape artist. These three small studies were all rendered with graphite pencils on Arches hot-press paper.

This is a close-up of a very small pond. Here, interest was created by the placement of the weeds and the reflections in the water.

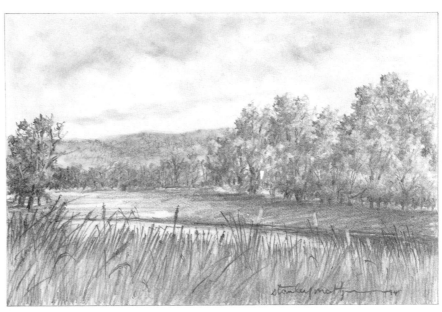

Ponds are often partially hidden by weeds and cattails, which are usually found around these small bodies of water. Woods and the mountain in the background round out this small landscape.

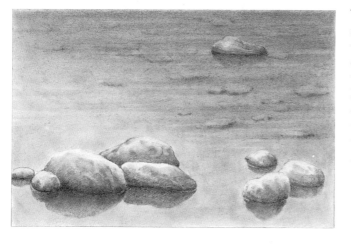

This drawing shows reflections of rocks in a quiet pond. The mirror-like reflections are very sharp; no ripples are present because of the bright day. To capture the feeling of rocks under water, leave the value of the water the same overall and make the contour darker. Or, if the sun is overhead, make the tops of the rocks under the water lighter and include the outline with a little shadow.

DRAWING WATERFALLS

Preliminary Sketch

The crashing sounds of rapidly running water moving over rocks create a quite different, but equally enticing, mood from the stillness of a pond. I started with a thumbnail sketch that shows very little detail but does show the placement of values and the flow of the water. It was worked on tissue paper with graphite pencils.

Outline Sketch

A contour, or outline, sketch was made to position all the elements. I also spotted a little tone here and there as guides to help me locate areas more quickly. At this point, I decided to do the finished drawing on a piece of 4-ply museum board using charcoal pencils.

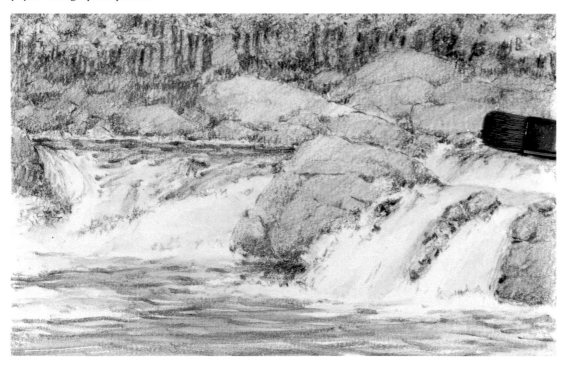

Laying In Values

I begin laying in values with a 2B charcoal pencil. In the dark areas, I use a 4B pencil. The falls are left as untouched paper with just a little water direction added at the base of the falls and foreground with a 2B pencil. I add some detail in the wooded background and a little in the rocks—not too much. If you add too much, the next step would simply wash much of it away.

Next, I use a damp brush to paint over the charcoal. (The brush should be cleaned with fresh water when working the dark areas, or they will get too dark.) With the charcoal residue left on the brush, I add a bit of light gray to the sides and base of the falls. (Remember to follow the flow of the water with your brushstrokes.) When the water has dried, I work over the drawing with various charcoal pencils. I add some nice darks on the rocks next to the water; this will make the water look whiter. I keep the rocks dark at the base of the water, as they are always wet.

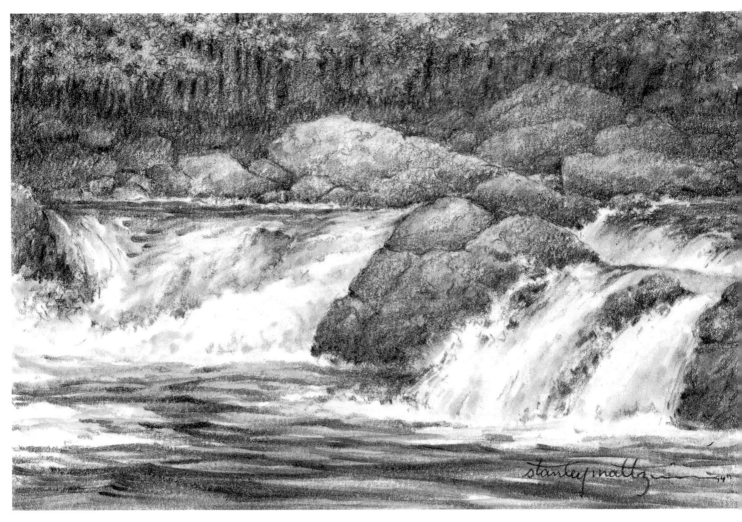

Adding Details

A little more detail, such as crack lines and shadows here and there, is added to the rocks. Notice the interesting textures on the rocks created by brushing water over the charcoal. Don't overwork and destroy this happy accident. Finally, I add some dark strokes to the water in the immediate foreground. I find that when indicating water in a drawing, it's best to keep it as simple as possible to keep from getting a labored look.

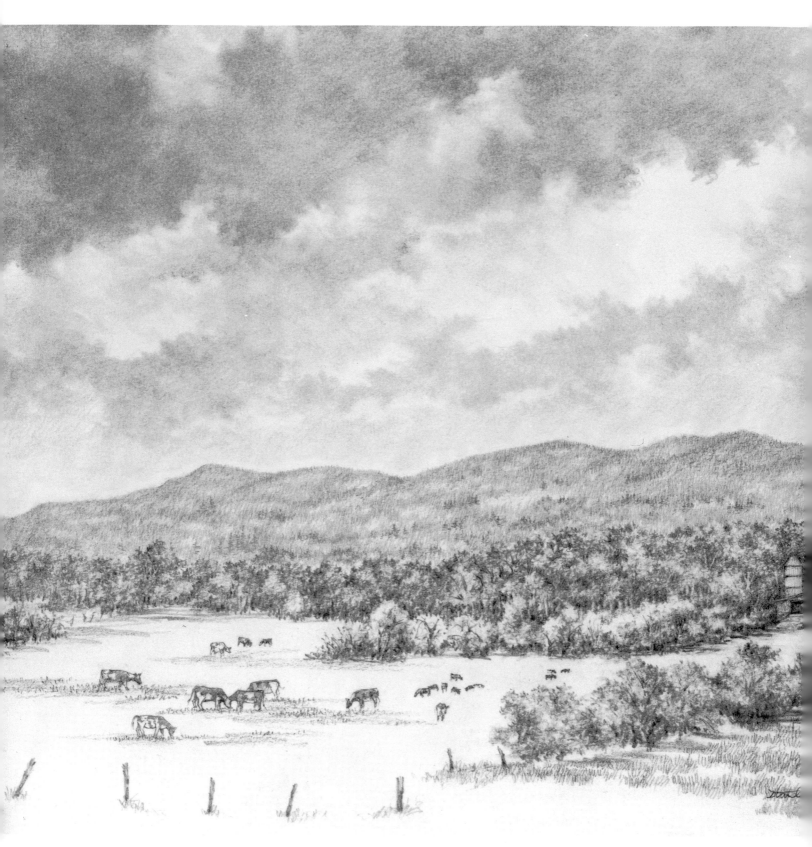

Valley Farm, graphite pencils on Somerset textured paper.

Drawing Nature in Various Mediums

Up to this point, we have been discussing the many elements that go into composing a landscape. Now we begin to put it all together with a look at some landscapes done with various drawing materials on a variety of papers and surfaces. For example, the drawing at left was rendered with several hard- and soft-leaded graphite pencils, which, when combined with the textured-surface paper, lent a richness of tone and texture. These examples are not the last word on landscapes. There are no formulas. What I am trying to do here is stimulate your thinking. Take what you've learned, add to it, and improve upon it.

DRAWING THE LANDSCAPE WITH PENCIL

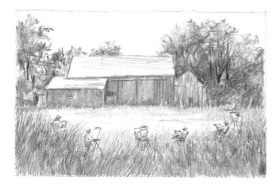

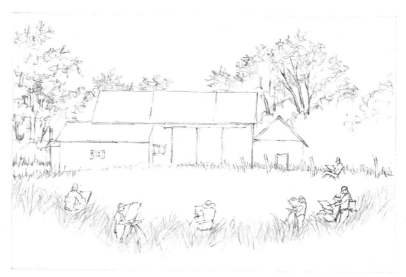

Preliminary Sketch

The barn and background were indicated in a scribbly manner with the flat edge and side edge of a carpenter's pencil. I then shifted to an HB graphite pencil and added the students sketching in the field.

Step 1

With an HB graphite pencil, I reworked the drawing to improve details and simplify the figures. I moved one figure, eliminated a sitting figure, and added one more standing figure—subtle changes that add more interest. Notice that the outline is kept light, making changes easy to carry out.

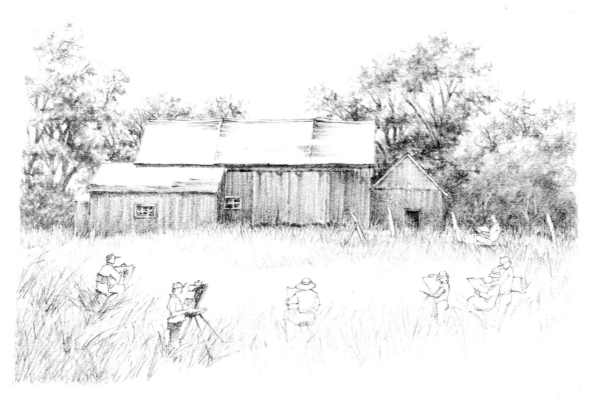

Step 2

With a carpenter's pencil (for the barn siding), B and 2B graphite pencils, I started adding tone to the elements to determine how the values would work next to one another. Some of the background trees were brought to a degree of completion to help set the proper values for the buildings. With a carpenter's pencil thinned down on the sides with a sand block, the barn siding was finished with strokes made from top to bottom.

The grass was worked with an HB pencil and finished with a B pencil for emphasis in the dark areas. The figures on the left were finished to see how they would fit into the overall picture.

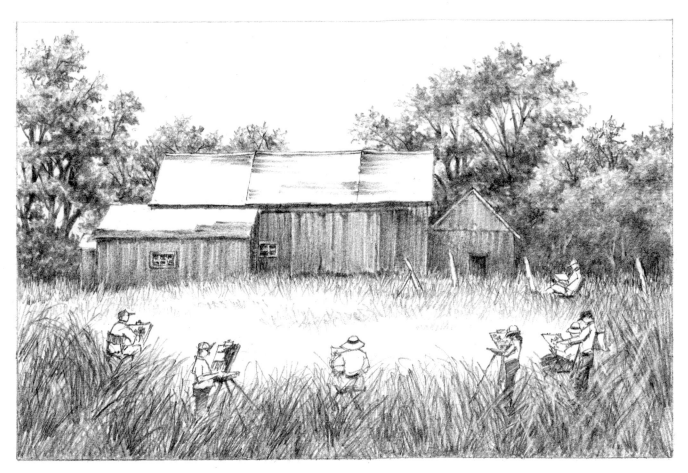

Step 3
Liking the looks of the two figures, I finished the remaining figures and added some accents to the foreground grass to properly set the figures into the grass. A word of caution when inserting figures in a landscape: Keep them simple unless they are the center of interest.

Hudson River Workshop, 4⅞″ × 7¼″, graphite pencils on Whatman printmaking paper, matte finish.

DRAWING THE LANDSCAPE WITH CHARCOAL AND WASH

Now let's experiment with the use of charcoal and a color wash. Gather the following materials: a tube of watercolor paint in ultramarine blue or another dark color; a large, round brush (no. 14), or a 1-inch flat brush; some pieces of 6″ × 9″ museum board (mat board) or heavy watercolor paper (300-lb.); a piece of wax paper larger than your board; a water container; a mixing dish; newspaper; and four heavy items, such as stones, to be used as paperweights.

Step 1
Squeeze a little blue paint into your mixing dish and add water. You want to end up with about a 60 percent value of the blue.

Step 2
Dip your brush in the mixture, and starting from the top of the paper, go back and forth with the loaded brush. Dip again, and catching the bottom of the previous stroke, repeat the step until you cover the entire board. Make sure you have plenty of paint on the board.

Step 3
Lay the painted board on top of a sheet of newspaper to keep things clean. Quickly cover the board with the sheet of wax paper.

Step 4
Pull the tips of your fingers from the top of the wax paper to the bottom, causing the paint to be pushed aside. Make only vertical strokes. Air bubbles and "blisters" will appear underneath the wax paper, creating all kinds of shapes in the paint. Every time you drag your fingers down the paper, you will change the shapes. Too much rubbing will result in a sheet of blue paper, so do it once or twice and let it dry. Put weights on the paper's edges and leave it to dry overnight.

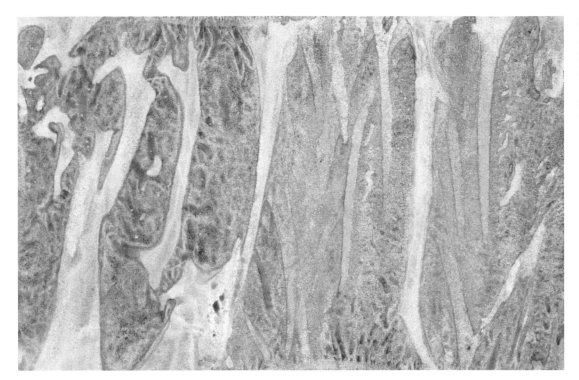

Step 5
Remove the wax paper. You should have a kind of "enchanted forest" of various tree shapes.

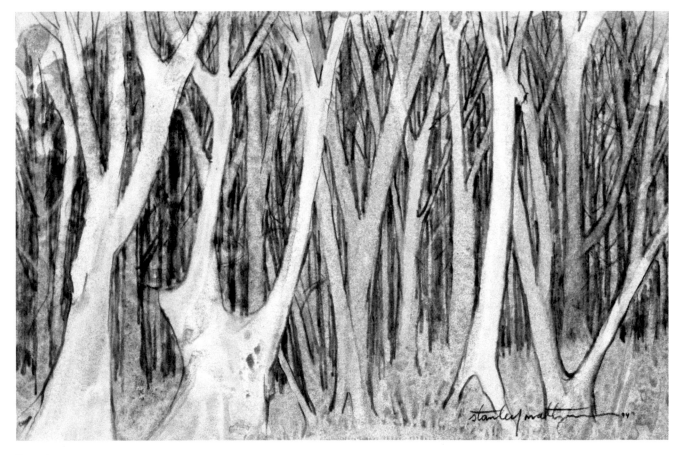

Step 6

Use charcoal to bring the forest to life by adding line and tone to the shapes. You do not have to stay with one color. Be daring and glaze colors, but make sure the original color is bone dry, and add the color before you work with the charcoal. Start with one color and drop additional colors on top before covering with wax paper. You might even start with a colored stock. Experiment and have fun!

CHARCOAL AND CONTÉ SANGUINE

Part of the enjoyment in drawing is the variety of papers and surfaces to work on, as well as the many mediums available to draw with. For this drawing, I chose a piece of Ingres Antique laid paper in earth color. This is a mould-made paper with lines embedded during the manufacturing process. I used a sanguine drawing pencil made by Conté. Sanguine is reddish in color, though Conté makes various shades of sanguine; you may want to try them all to see what you prefer.

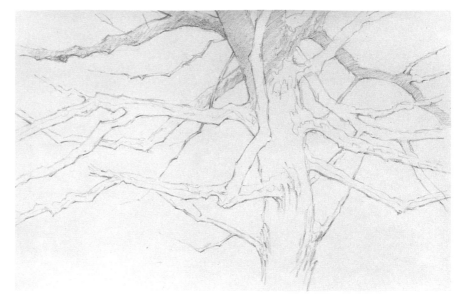

Step 1
This is a sketch of a walnut tree outside my studio. I began with a line or contour drawing, adding some tone at the top to give me a sense of direction.

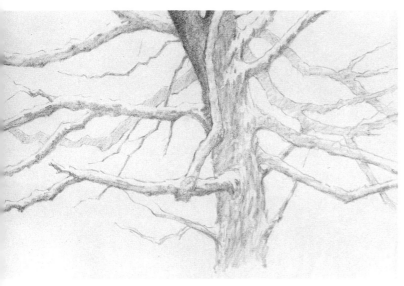

Step 2
I continued drawing with the sanguine in a sketchy way, without too much detail. Then, with a 2B charcoal pencil, I lightly added some tone at the top, again just to get a feel for what I wanted to do.

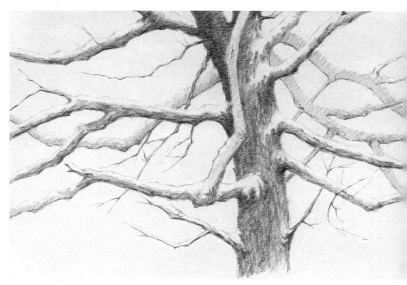

Step 3
With the charcoal, I emphasized the darker values on the undersides of the branches and where the branches join the trunk, being careful to let some of the sanguine and the colored paper show through.

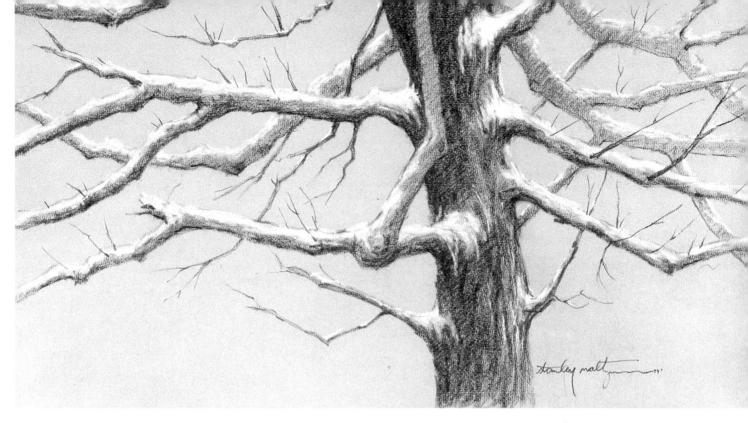

Step 4
Finally, with a piece of soft white pastel, I added some snow, varying the thickness and keeping the white lines uneven. Notice how the snow has been caught in parts of the bark, which gives the impression of a driving snowstorm rather than gentle flurries.

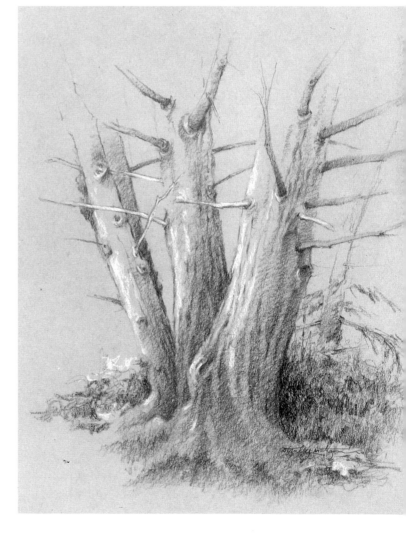

Here's another example done with charcoal, sanguine and white pastel. In this drawing, the white was kept to a minimum; it was used only for highlights. I used simple, heavy brown wrapping paper, which shows you can find interesting drawing paper just about anywhere.

CHARCOAL AND WATERCOLOR

Preliminary Sketch
This is a charcoal thumbnail on tracing paper of a Catskill sunset. I don't make color roughs when working with charcoal and watercolor. I work from memory or directly from nature.

Step 1
On my good paper, which is 4-ply museum board, I lightly indicate some clouds and mountain ranges with my 2B charcoal pencil. I am more concerned here with values than with details, because when the watercolor washes are laid over the charcoal, some of the charcoal may wash out.

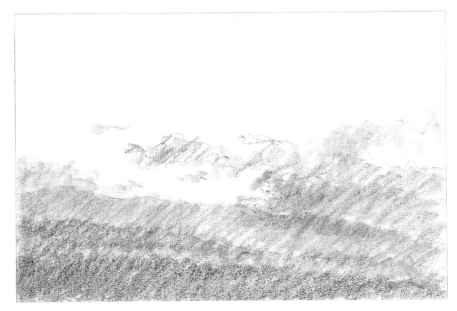

Step 2
I begin sketching in the trees over the clouds and mountains, developing interesting patterns and making some trees short, some tall, some thin and some thick. I can always add more later if I want more density in the tree line.

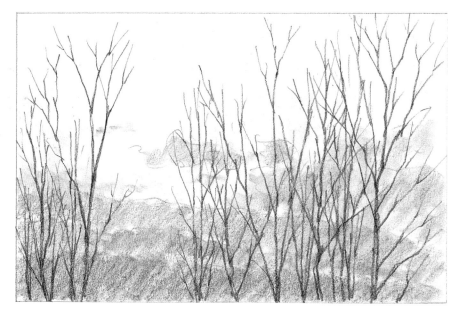

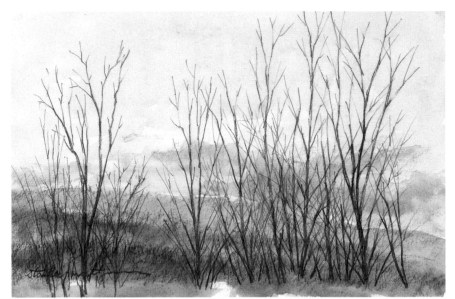

Step 3
Now I'm ready to add watercolor. I usually start with the sky and work toward the bottom. Be careful in areas where there is a heavy concentration of charcoal. The watercolor brush will naturally pick up some of that charcoal and may transfer it to areas you want to remain light. To prevent this, rinse the brush in clear water and reload with your watercolor.

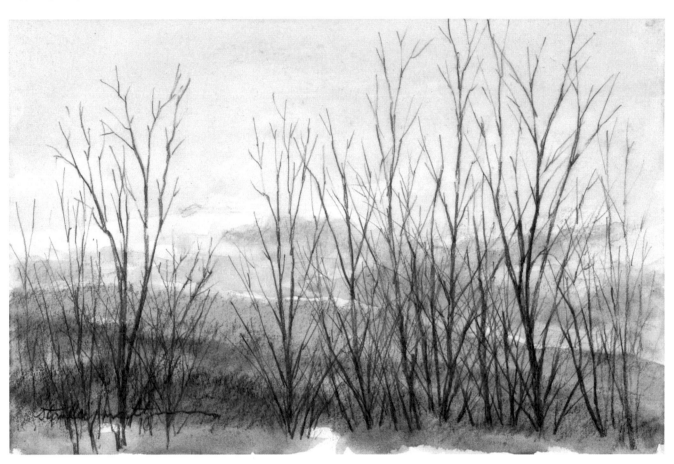

Step 4
A few minor corrections will improve this picture. I wash a very light violet over the top of the existing sky, then add a brighter, yellow-orange sunset streak. (Hint: Before you make any correction in watercolor, always wet that area of the paper with clear water. This will prevent hard edges and allow the revision to blend right in.) Finally I add a few more trees on the far right and left with a charcoal pencil, and *Evening Prelude* is finished.

Catskill Creek
This quick sketch done with charcoal and watercolor contains the barest amount of detail, yet it has a spirit that will enable me at a later time to compose a larger, more finished painting.

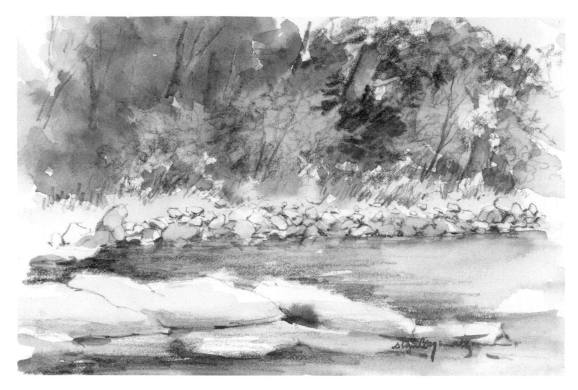

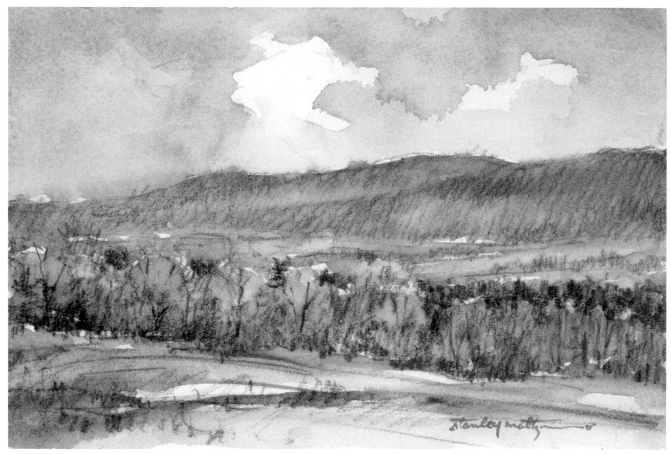

Fall Landscape
This little sketch worked so well that I never tried to make a larger painting. Quite often, these charcoal and watercolor sketches capture something that seems to be lost when you try to do them larger.

DRAWING NATURE

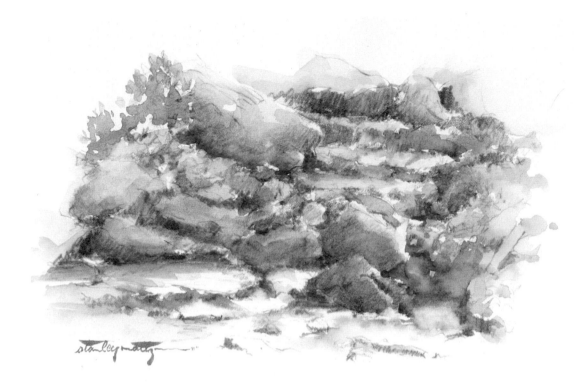

Little Falls
I came upon this welcoming spot while strolling in the woods. Charcoal and watercolor enabled me to record it with a minimum of time and trouble — just enough to get the feel of the place.

Fourth of July
This gazebo caught my eye late one evening. In spite of the lack of light and the dampness of the night air, I captured something that said, "Happy Birthday, America."

DRAWING THE LANDSCAPE ON COLORED PAPER

Working on colored or toned papers gives you the opportunity to stretch your imagination and creativity. For a winter evening scene like this one at right, for instance, you might think of working on a blue paper. In fact, the blue paper does give a pleasing effect of dusk changing to evening. But why not try another color? Quite a few darker colors would be effective for a night scene, as shown in the demonstration below.

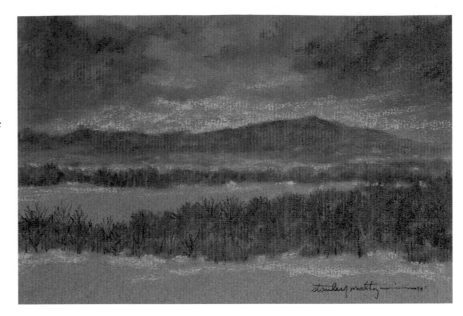

A piece of blue Fabriano Ingres paper became my midvalue background for a winter-evening scene. For the dark areas of trees, mountain and clouds, I used a 2B charcoal pencil and a piece of medium soft vine charcoal. The snow in the foreground and the evening light behind the mountain were done with a light-value, blue-violet pastel.

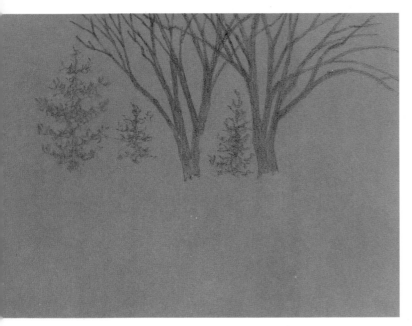

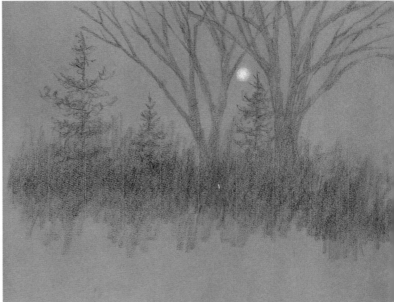

Step 1
I chose a sheet of Ingres Antique laid paper in a dark gray color called Smoke, and sketched in the background trees with a 2B charcoal pencil.

Step 2
Next, I turned to the middle ground. Using a little more pressure on my 2B charcoal pencil, I put down a darker value than the trees. This gives the impression of a dense woods. I also added the winter moon with some white pastel.

122　　　　　D R A W I N G　N A T U R E

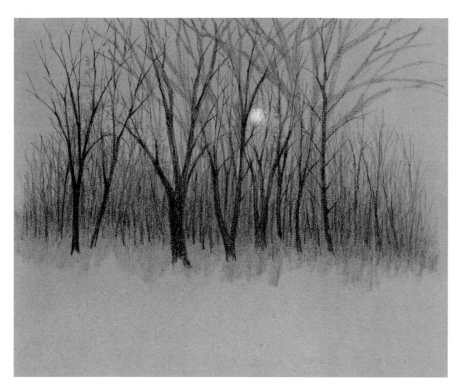

Step 3

Once the background and middle-ground values were established, I began adding trees over them without disturbing the tone. I varied the height and thickness of the trees to give a sense of perspective, placing the largest, most detailed trees in the foreground.

Step 4

With the forest completed, I began to work on the snowstorm. I piled the snow in the crotch of the trees, then very lightly, with a fine point on my white Conté pencil, I added snow on some of the thinner branches. With a piece of white pastel, I carefully stroked in some snow between the trees, then worked it into the foreground with broad strokes. (When drawing a snowstorm, you want to show enough snow for effect, but be careful not to overdo it.) Some saplings drawn with a sharpened 2B charcoal pencil completed the picture.

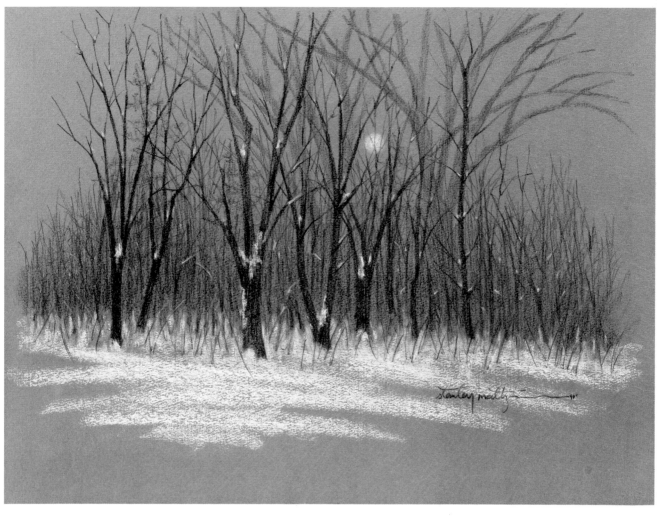

DRAWING NATURE IN VARIOUS MEDIUMS

DRAWING ON TONED PAPER

Toning your paper or surface before you start your drawing creates a midvalue color as a background, and with just two more values—a dark and a light—you can compose an interesting and unusual picture. There are many ways to tone paper, such as pastels, watercolors, gouache and acrylics, to name a few. Artists are constantly toning their canvases and overpainting with complementary colors for more interesting color effects.

For this demonstration, I'm using acrylic paint in burnt sienna for my mid-value, charcoal for my darks, and a yellow-orange pastel for my lights. The other materials needed are: a small mixing dish, a container of water, brushes, rags, and a hair dryer to speed drying the paint. The surface is 100 percent rag, four-ply museum board.

Step 1
Dip your brush into the mixture of acrylic paint and water, and apply the paint to your paper or board. (Try out your color on scrap paper until you have the tone you want.)

Step 2
Create whatever textures you want with your brushes.

Step 3
Cover the entire board with paint, and if you are satisfied with the surface texture, let it dry.

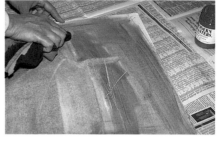

Step 4
Additional texturing can be done with a rag or by scraping or scratching with a palette knife, a piece of scrap board, or anything else that will give you the effect you want.

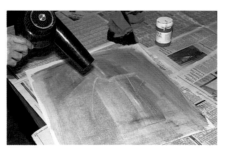

Step 5
If you are in a hurry, a hair dryer will speed up the drying process.

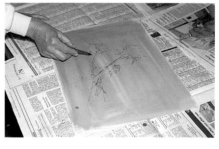

Step 6
When your toned surface is dry, begin sketching with your pen, pencil, charcoal, pastel or any other drawing medium.

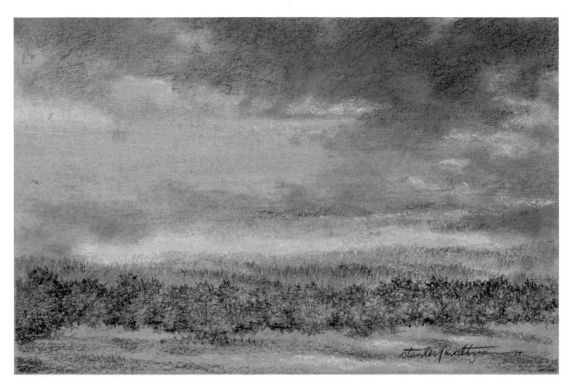

Step 7
To complete this
drawing, I had to
use only two
more values—
charcoal for the
darks and a stick
of yellow-orange
pastel for the
lights.

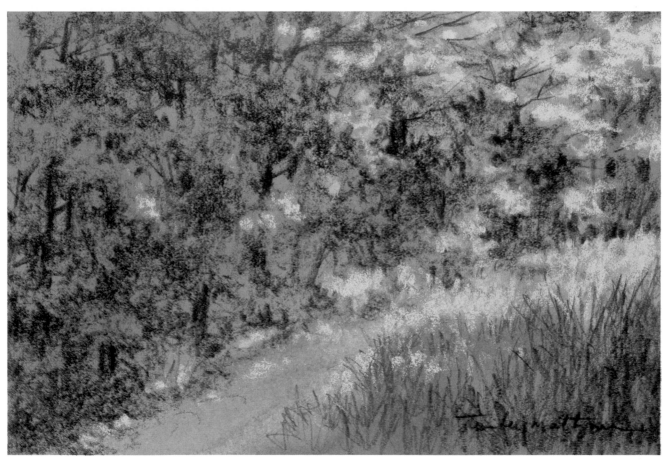

For a completely different effect, here I used Hooker's green watercolor to tone a
piece of 4-ply museum board. When the watercolor was dry, I used a 4B charcoal
pencil and a stick of lemon yellow pastel to do the drawing.

DRAWING LANDSCAPES BY LIFTING OUT TONE

Here is an interesting and unusual way of composing a landscape. You could think of it as "drawing in reverse," where you start with a dark-toned surface, then lift out your landscape elements with a tortillion, rag, eraser or even your finger. Here I've used charcoal powder, but you could also use any dark-colored dry powder pigment.

Step 1
Gather together your materials for this project: charcoal powder or any other dark-toned dry pigment, vine charcoal, charcoal pencils, tortillions in various sizes, soft rags, kneaded and white plastic erasers, and a gray or any other color paper or board. Place some newspapers over your work area, as charcoal powder can make a mess!

Step 2
Sprinkle some charcoal powder on your gray paper or board and rub it in with a soft rag. Add enough charcoal to make a very dark value — as close to black as possible.

Step 3
Continue rubbing in the charcoal until you cover the area you're going to work.

Step 4

Begin "drawing in" your landscape elements by removing charcoal with the tortillions, rags, erasers, tissues or your fingers.

Step 5

Continue removing dark tone to create your shapes, being careful to wipe the removed charcoal on a rag or tissue so you don't transfer it back to the picture.

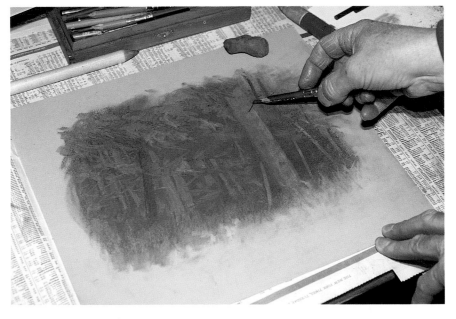

Step 6

After you've lifted out the shapes you want, you can then work back into your drawing with vine or charcoal pencils to add details, emphasize shapes, or make an area darker.

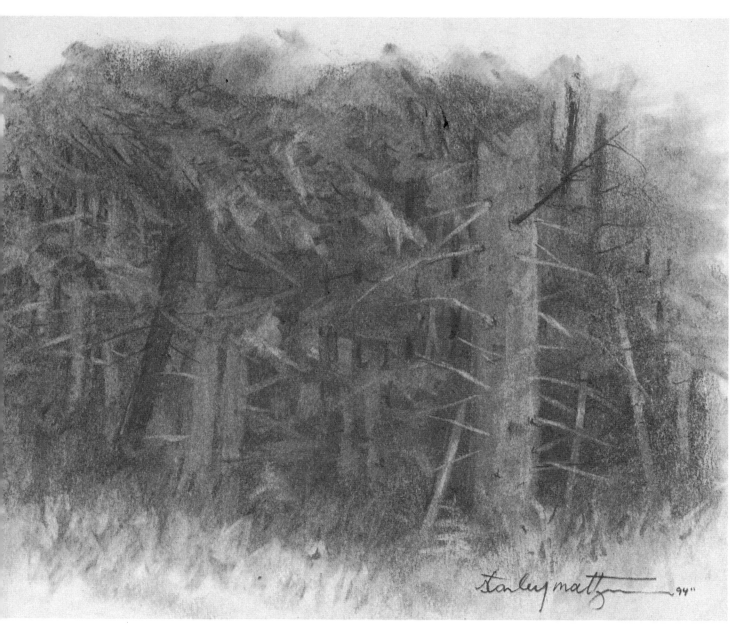

Step 7
The finished result depicts a mysterious, moonlit forest. Try this same procedure on any color of paper or surface — even white — for surprisingly different effects.

Conclusion

We have strolled through the fields and forests, walked up the mountain and gazed at the sky, and as we walked, I have tried to make you aware of the multitude of pictures available everywhere you look.

I have tried to inspire you to take a chance and to remember that your perseverance will make the difference between success and mediocrity. Start your thousand-hour pencil drawing . . . today!

Don't hesitate to try something different, even if it's as basic as new pencils or papers or new combinations of materials.

In this book, I hope I have conveyed to you the feeling I have for drawing and have stimulated your interest in this flexible and versatile medium.

The most important thing is to be yourself and do not become discouraged. It is true . . . tomorrow is another day.

Tips on Storing and Framing Your Drawings

USING ACID-FREE STORAGE MATERIALS

Now that you have accumulated quite a few drawings, storing them can become a problem; so I'd like to recommend several easy ways to protect and preserve your drawings for future display.

Never lay your drawings on a wood shelf or in a wooden drawer (like the beautiful old wood blueprint files) unless you separate the drawings from direct contact with the wood. The acid in the wood will eventually stain any paper it comes in contact with, leaving brown stains on your artwork. You can avoid this problem by inserting an acid-free barrier between the wood and your pictures or papers. This type of barrier is known as *conservation* or *museum board*. You can make a shelf liner out of 2- or 4-ply museum board, as illustrated at right. Acid-free paper, called *barrier paper*, may also be used as a shelf liner. What they all have in common is a neutral pH. The pulp that goes into the manufacturing of the board or paper goes through a buffering process that neutralizes the paper's acidity. This helps prevent discoloration and deterioration of artworks on paper, like drawings and paintings.

I also suggest getting into the habit of placing a sheet of acid-free barrier paper between each piece of art. A package of paper will last a long time, and the sheets can be used over and over.

Do not place large drawings on top of a stack of smaller drawings. Rather, make a pyramid with the smallest sheets on top. Or, if you have the room, make a separate stack for smaller sheets. You want to keep the paper as flat as possible to prevent waves and ripples from forming on your paper.

Another method for storing your work is with an archival box. These boxes come in various sizes up to 20″ × 24″ × 3″ with a drop front. For larger works, you can use portfolios, but be sure to put barrier paper between the front and back cover and between each piece of art.

MATTING YOUR ARTWORK

Matting your artwork when framing not only enhances but protects your picture

Shelf Liner

To make your own shelf liner out of acid-free museum board:

A. Measure the base of your drawer or the width of your shelf, and mark the size on your museum board.
B. Allow about three or four inches for the shelf sides.
C. Cut away the corners.
D. Score along the dotted lines and fold up sides to form a box.
E. Tape the corners with acid-free linen tape or white artists' tape. Cut tape at corners and fold inside.

Archival Box

Mats

as well. The mat keeps the glass from coming in contact with the art, and it allows for breathing space. If condensation should form on the glass, it will not come in contact with your art.

It's very important to use high-quality board for your mats. Museum board and conservation board are made with a solid core, that is, the color is throughout the whole board. The surface and the core

are all neutral pH. You can use either side of the board for the front of your mat and the core will not change color over time. This board does cost more, but you will never have to worry about your artwork having a brown stain around it. Also, there is no waste—you can use the scraps for drawing and painting.

Wood Pulp Board

This is made by chemically treating and washing the wood chips to eliminate the resins and gums to make a paper with a neutral pH. Wood pulp is used in many types of boards, and if not treated, will discolor in a short time. The word *pulp* is a term applied to the mixture of the fibers, whether it be cotton, wood, leaves or whatever, that the board is made from. For long-term framing, using high-quality museum board is the safest way to go.

CUTTING THE OPENING IN THE MAT

Your window or opening in the mat is naturally going to be determined by the size of your artwork. Take some scraps of mat board and cut them into strips 2½ inches wide. The lengths can vary. Lay the strips on the edge of your art and move them up and down, in and out, till the opening is the right size. (You should cover at least ¼ inch of your art with the mat on all four edges.) Then measure the opening and mark your mat board for cutting.

HOW WIDE SHOULD YOUR MAT BE?

Choosing the width and the color of your mat is a matter of personal taste. Artwork framed in your studio can look entirely different on someone else's wall. As I mentioned before, the mat protects and draws attention to your artwork. Dark colors tend to enclose, and lighter colors make the art look larger. If you have a very small piece of art, a larger mat will help draw attention to it. If you have a piece of art about 8″ × 10″, 9″ × 12″ or so, then a 2½″-wide mat would be a nice size. For large pieces, 15″ × 22″ or 22″ × 30″, a mat of 3½″ to 4″ would be very accommodating.

When cutting the opening in your mat, if you make all four sides the same width, the bottom width will appear smaller. To compensate for this optical illusion, make the bottom width ¼″ to ½″ wider than the top and sides.

Finally, when you are selecting the color of your mat board in the store, you

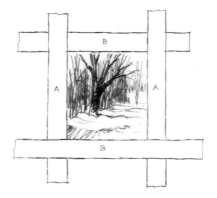

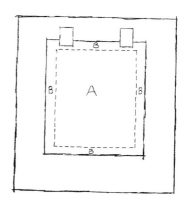

Move strips *A* in and out, and move strips *B* up and down to determine the opening in your mat.

The mat opening (*A*) should overlap the art (*B*) by at least ¼ inch.

A mat with all four sides of equal widths tends to make the bottom strip look smaller. Always leave ¼ inch to ½ inch more on the bottom strip, whether your picture is vertical or horizontal.

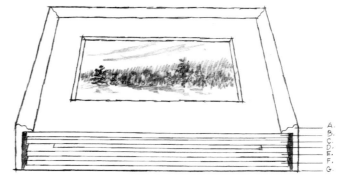

A properly framed piece of art is a sandwich of several layers:

A. Molding
B. Glass
C. Mat
D. Art
E. Museum-quality backing board
F. Foamcore or corrugated board backing
G. Paper seal taped around all four sides

will be looking at the colors under fluorescent or incandescent light, and you will not get an accurate reading. Try to look at the board in natural light near a window for a true reading of the color.

WHAT IS A BACKING BOARD?

A *backing board* is used behind your artwork as a support. As you are going to

attach your work to this board, it should be strong enough, and should be of museum or archival quality (that is, acid-free). The backing board will be the same size as your mat. You will then add another board of either corrugated cardboard or foamcore behind the backing board. Be sure to place a barrier sheet between the two boards.

ATTACHING YOUR ARTWORK AND MAT TO THE BOARD

To attach your mat and your art to the backing board, use an acid-free linen tape or make your own hinges from Japanese rice paper. The rice paper can be attached with a wheat or starch paste that should include a fungicide. A good paper with strong fibers is Mulberry paper. One sheet will make many strips for hinges.

GLAZING

There are many factors to consider when deciding whether to use glass or plastics (acrylic, Lucite or Plexiglas) to protect your artwork in its frame. Glass will break; plastic will not. Glass is much heavier than the plastics. Plastic will turn yellow in time from light, and it does scratch easily. Never use glass cleaner on plastics; clean only with a plastic cleaner, and wipe with a very soft cloth. (Watch the rings on your fingers.) Do not wipe with newspapers; they are too harsh.

Glass comes in regular and nonglare. Nonglare glass has a tendency to distort, which can be disturbing. The distortion is most noticeable when you look at a picture from the sides.

Both glass and the plastics are manufactured with ultraviolet filtering and will do a good job of filtering out ultraviolet rays. The cost of this material is much more than regular glass and plastic. Ask prices before ordering so there is no misunderstanding with your framer.

Plastics always retain a form of static electricity, which can lift particles of your drawing right off the paper. There are antistatic sprays on the market, but they do not last for any length of time. To remedy this situation, be sure to fix your drawings very well. Use several light coats of a spray fixative rather than one heavy coat.

MOLDINGS

Because framing is so costly, it's only natural to want to frame your work with as nice a molding as you can at a reasonable cost. One way is to go to a lumberyard and buy some molding, then cut and assemble the frame, and apply a finish. All very time consuming. Another, more practical, way is to find a framer who can sell you moldings. You'll have a wider selection than at a lumberyard, and you eliminate the finishing. Besides buying strips of molding, you can order your selection cut to the size you need. You are

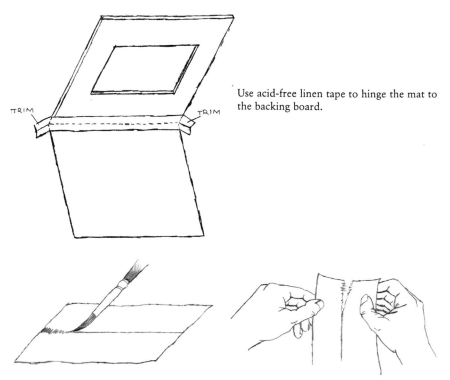

Use acid-free linen tape to hinge the mat to the backing board.

If you want to use rice paper instead, score and wet the paper, then tear it along the wet line.

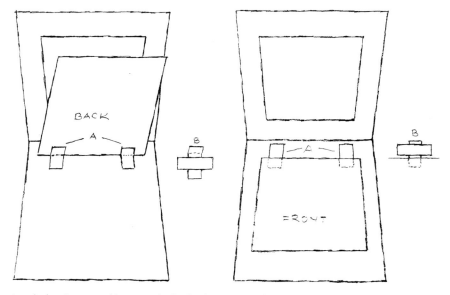

Attach the rice paper hinges to the back of your art and to the front of the backing board, as shown in A. If you use linen tape, make a T-hinge, as shown in B.

assured of accurately cut corners, which are essential for a nice-looking frame.

But the most practical way is to select a molding from a frame factory catalog, measure your mat, then order your molding by giving the size of the mat (outer dimensions) and the molding number. The frame will come back to you all assembled with an extra ⅛ inch breathing space. I mention this ⅛ inch breathing space because when you frame

with a mat, backing board and corrugated or foamcore board, you have to allow space for expansion and contraction. Do not fit the material tightly against the molding, as it will buckle, and taking things apart to correct this problem can be annoying.

Carved Moldings

I don't think there is anything more beautiful than a hand-carved frame, but

DRAWING NATURE

they are quite costly. You also have to keep in mind that your frame should not dominate your drawing.

Gold or Silver Leaf

These two finishes make a nice molding to frame your drawings. Cost will vary greatly, depending on whether you are buying real gold or silver leaf, or imitation leaf finishes. The imitation leafs must be sealed or coated, or they will tarnish. I have not had any problem with the sealed imitation leafs and find them an excellent substitute for the real thing. If you ever have the opportunity to watch someone applying real gold leaf, go for it—it is a wonderful experience.

METAL FRAMES

Metal frames come in various finishes and colors. They are very economical, which makes them popular, and I think they look great with posters and commercial prints. One disadvantage is that you do not get a good seal with them. When you use metal frames, periodically check the screws in the back to make sure they are tight. Also, do not pick up a larger metal-framed picture in the middle; always use two hands, and pick it up holding the sides.

PLASTIC FRAMES

The only plastic frame worth talking about is usually in the form of a plastic box. They work well in a modern decor, but remember, unless they are made from ultraviolet filtered plastic, they are going to turn yellow. Be sure to use archival quality mat and backing. Do not put artwork flush against the surface of the plastic.

USING THE RIGHT MOLDING FOR YOUR PICTURE

The shape, size and color of the molding can make or break your picture. A heavy, dark molding tends to enclose your work, whereas a lighter molding seems to recede and let the art dominate. A molding that curves from the back to the front gives you the feeling that the picture is coming forward. Don't let your molding width compete with your mat. The molding should be narrower than the mat. Only by actually trying various moldings will you be able to develop that sense of balance. Don't be embarrassed to ask for a sample, even if there is a small charge. This gives you a chance to accu-

Moldings come in a huge variety of styles, shapes and colors. Acquire as many samples as you can to try out with your artwork in your home or studio.

The frame and mat should work together as one unit to present your artwork without distracting from it.

mulate samples so that you can make your decisions at home without feeling influenced or pressured. The main thing to remember is that the molding, the mat, and the drawing should become a whole unit. The mat calls attention to your drawing, and the molding ties them all together.

INDEX

More Great Books for Artists!